Historic Tales
of
ARLINGTON
TEXAS

Historic Tales

of

ARLINGTON TEXAS

EVELYN BARKER

WITH DAVIS MCCOWN, LESLIE WAGNER AND TREVOR ENGEL

THE
History
PRESS

Published by The History Press
Charleston, SC
www.historypress.com

Unless otherwise noted, all photographs in this book are from UTA Libraries Special Collections, particularly the *Arlington Citizen Journal* Negative Collection, the *Fort Worth Star-Telegram* Collection and the J.W. Dunlop Photograph Collection.

First published 2018

Manufactured in the United States

ISBN 9781625858955

Library of Congress Control Number: 2018936068

Notice: The information in this book is true and complete to the best of our knowledge. It is offered without guarantee on the part of the authors or The History Press. The authors and The History Press disclaim all liability in connection with the use of this book.

To Bob with love.

Contents

Acknowledgements

T hank you to the University of Texas at Arlington Libraries Special Collections for its unwavering support, especially Brenda McClurkin and Cathy Spitzenberger. Unless otherwise noted, all photographs in this book are from UTA Libraries Special Collections, particularly the *Arlington Citizen Journal* Negative Collection, the *Fort Worth Star-Telegram* Collection and the J.W. Dunlop Photograph Collection.

Thank you to Davis McCown, Leslie Wagner and Trevor Engel for their expert contributions to *Historic Tales of Arlington, Texas*. I am grateful to have been able to work with you on this project.

Thank you to Lea Worcester for her years of guidance and support that ultimately made this book possible. You were with me in spirit for every word.

As ever, thank you to Bob, Will and Scott for their patience and understanding through the many months of work on this book. You are my rock, my joy and my heart.

4:10 to Arlington

The first thing you noticed was the low, deep-throated whistle that carried for miles on the open prairie. Then you would see a plume of dark-gray coal smoke and soot rushing up and away from the smokestack as the steam train chugged toward the small Arlington station. Burning lubricant gave off a smell like rotten eggs, and escaping steam hissed and engulfed the engine in billowing white clouds.

Arlington was platted in 1876 as a stop for the Texas and Pacific Railroad connecting Dallas and Fort Worth. Typical of railroad towns, Arlington grew quickly and soon offered settlers a post office, a general store and a smithy. By 1892, the population had grown to about 750, and the town was sporting a number of grocers, banks, restaurants, dry goods stores and saloons. Eleven trains a day rumbled through the town. They were a part of everyday life.

But murder was not.

Walker Hargrove was a weedy young man with a scraggy moustache and a proclivity for violence. In the first recorded instance of him shooting a man, Walker, twenty, had been drinking heavily at Ridgeway's Saloon in Hell's Half Acre—a section of Fort Worth renowned for saloons, gambling parlors, dance halls, vice and prostitution.

He stumbled into Bill Williams, an African American hotel cook, around midnight on March 31, 1890. When Williams turned to look at the offender, Walker growled, "What are you staring at?" "At you," Williams retorted,

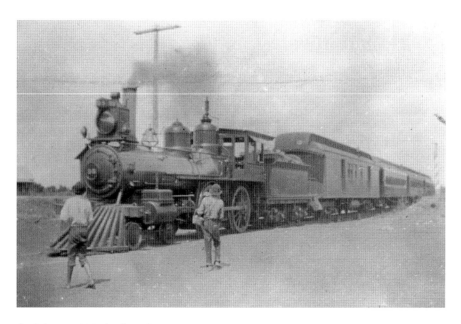

On July 19, 1876, the first of many trains came through Arlington. This photo of a Texas and Pacific locomotive was taken in 1896.

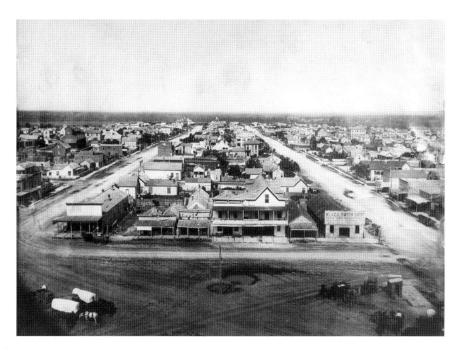

Fort Worth, as seen from the top of the Tarrant County Courthouse, circa 1888.

turning back. Walker took offense at that answer and fired a shot that went through Williams's lower back and out the front.

Williams collapsed to the ground, and Walker ran out of the saloon. He gave himself up to the marshal the next day, though, and told his own version of events. According to Walker, Williams slashed him with a razor; he showed the marshal a gashed shirt and undershirt as proof. Walker said he feared for his life when he shot Williams.[1]

Williams's wound was so severe that most thought he'd soon die, but he didn't.[2] Walker never went to trial.

The next man Walker shot wasn't as fortunate. Trouble had been brewing between Walker and Henry Tackett after a fight over a woman "whose affections," said the *Fort Worth Daily Gazette*, "anybody could have bought quite cheap."[3]

According to Walker, he was in the My Office Saloon when Tackett and another man attacked him. "Tackett and a fellow named Doc Winfrey, both big men, picked a quarrel with me….I don't know why they wanted to fight me. Winfrey said he thought he was a better man than I, I admitted he was bigger, but I thought he would have some trouble doing me up. Well, they waded in. Tackett held me while Winfrey cut me up."

The attack was severe enough that Walker was in bed for a week recovering from his injuries. While recuperating, he heard that Tackett planned to kill him next time they met. Nevertheless, on the afternoon of October 15, 1890, Walker returned to My Office. He sat at a table, sipped a beer and watched Tackett flirt with the object of their mutual desire in the back part of the saloon.

Then Tackett looked up and saw Walker eyeing them. Tackett advanced on Walker and hit him in the shoulder, cursing and threatening to start another fight. Walker, afraid that Tackett planned to kill him, drew his pistol and shot Tackett in the chest. Tackett's friends, however, had a different version of events. According to them, Tackett came over to Walker's table, clapped a hand on his shoulder and was asking kindly after Walker's health before being attacked.

Walker shot Tackett two more times before fleeing the saloon, only to be captured two blocks away. He was swiftly sentenced to five years in the state penitentiary for manslaughter but was just as swiftly acquitted in a second trial.

Walker came by his deadly nature honestly. His father, George Hargrove, usually referred to as "Old Man Hargrove," was a well-known horse trader in Fort Worth with a history of fights, thefts and questionable horse deals.

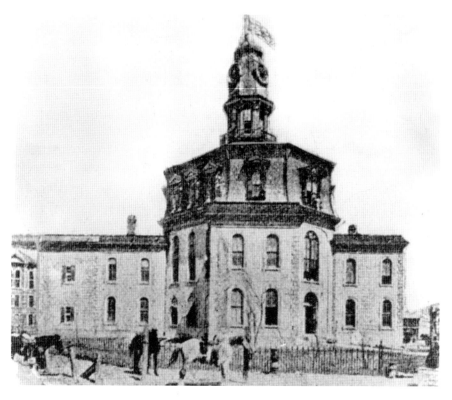

Tarrant County Courthouse, circa 1882–94. The present courthouse opened in 1895.

In October 1888, Old Man Hargrove was involved in a midnight gunfight near the Tarrant County Courthouse. Liquor was involved, as was an unlucky game of dice. Old Man Hargrove shot at a man but missed and hit two male passersby in the face with birdshot.

"It's that damn fool Hargrove trying to kill me!" the intended victim yelled as he ran by the wounded men.[4]

Upon questioning, Old Man Hargrove said that the man grabbed him by the throat, made threatening statements and shot at Hargrove first.[5] Since no one died and the passersby were not seriously injured, it appears police did not pursue the incident.

Two months later, Old Man Hargrove was again in trouble, this time with his son Walker and a younger son who was unnamed but was probably George Jr., called George. The altercation took place at a racetrack after an afternoon spent betting on the horses. George and a man named Dave Flood had started feuding days earlier. When they saw each other at the

track, they decided to continue the argument then and there. As the two men landed blows on each other, Walker joined the fight, making it two against one. In response, Flood ripped a wooden paling off a nearby fence and walloped Walker in the head, knocking him down.

At this, Old Man Hargrove pulled out a dirk and joined the fight, stabbing Flood twice in the shoulder. Flood's friends seized Old Man Hargrove and wrestled his knife from him while Flood and George continued brawling. Then Old Man Hargrove took a cue from Flood, wrenched another paling from the fence and bashed it into the left side of Flood's head. This ended the fight.

A doctor examined Flood's head and concluded that "beyond a slightly annoying headache, the blow on the head would cause him no inconvenience."[6]

Police released Walker and George, but Old Man Hargrove was charged with assault with intent to murder. A jury found him not guilty in April 1890.

The *Fort Worth Gazette* noted, "[The Hargrove boys] have been in innumerable scrapes of almost every description, more or less serious, at one time hardly a week being allowed to pass that one or both were not pulled for making gun plays, carrying concealed weapons, or similar offenses."[7]

But there was one man who would, without hesitation, stand toe to toe against the Hargroves: Harvey Spear of Arlington. Spear was sixteen when he joined the Confederate army in 1862. He came to North Texas as part of Blanchard Debray's Twenty-Sixth Texas Calvary Regiment to fight in the Red River Campaign and, liking what he saw, moved to the area after signing his loyalty oath in 1865. Spear began farming and trading livestock in the area that would become Arlington, amassing 950 acres and more than one hundred head each of cattle and hogs.[8]

But his wealth did nothing to endear him to other Arlington citizens. One resident said that Spear was "regarded as one of the worst men who ever lived in that country."[9] Others called him dangerous, violent and most likely to carry out any threat he made. The *Gazette* characterized Spear as "a cool, brave man [who] would not go a rod out of his way to avoid a fight."[10]

Spear had his own brushes with the law. In about 1885, Spear entered a business arrangement with fellow farmer and cattleman Joe Elliott to take care of four hundred head of cattle for Spear. After two years, Spear complained that the cattle were being mishandled—an accusation that caused "bad blood" to spring up between the two men.[11]

In August 1888, Spear and his friend "Poker" Bill Smith (so named for his prowess at cards) drove from Spear's home to downtown Arlington in a

buggy. As Spear was putting up the horses, he asked a stable hand if Elliott was in town.

At that moment, Elliott stepped into the doorway of a grocery store across the street and fired a double-barreled shotgun at Spear. Buckshot tore through Spear's chest and arms, but he and Poker Bill returned fire, with Spear working the rifle with just one hand.[12] Someone shot a bystander in the face, though not fatally, and Poker Bill got hit in the arm.

When the firing stopped, Elliott, unhurt, escaped to the south, while Poker Bill helped Spear flee north. Spear's injuries and loss of blood were so great that newspapers reported his death, but Spear surprised everyone and recovered.

Spear and the Hargroves had known one another for about a decade and were friends as well as business associates. All that changed in 1892. In October, Spear and Old Man Hargrove entered an agreement for Hargrove to travel to East Texas and sell eight of Spear's horses. Hargrove gave Spear $100 for the horses with the understanding that he still owed Spear $205 but could keep any amount over that for which he sold the horses.

Something about the deal went sideways, however, prompting Spear to travel to Mount Vernon in East Texas and collect another $100 from Hargrove. Hargrove gave him the money but refused to pay the remaining $105, which led Spear to sue Hargrove for the balance. This action enraged Hargrove, and he tracked Spear to a Mount Vernon hotel, pulled out a six-shooter and would have shot Spear if not for all the hotel guests.

Spear ran out the back door of the hotel, with Hargrove in pursuit. When Spear reached the home of a Mount Vernon depot agent, Hargrove turned back and was arrested by the sheriff for disturbing the peace and brandishing a pistol. He was soon released.

Hargrove insisted that he had been swindled and put out the story that the horses Spear had given him to sell had been stolen. He demanded the return of the $200 he had paid Spear, but Spear was having none of it. Spear claimed that Hargrove had mortgaged his horses to one party and then sold them to someone else—selling them twice, in effect, and keeping the money from both sales.

Spear and Hargrove had no illusions about the fine character of the other, nor did anyone else who knew the two men. Everyone believed Spear and Hargrove were more than capable of carrying out violence. To forestall any bloodshed over the matter, intermediaries began trying to broker a resolution.

Hargrove said that if Spear repaid the $200, the matter would be settled, as far as he was concerned. Spear retorted that he could have all the Hargroves

killed for less than that and still have money left over. "I wouldn't give 10 cents to settle the trouble," Spear told a friend.[13]

Hargrove responded by sending Spear a note saying that if he did not pay him $200, Hargrove would kill and burn everything at Spear's home in Arlington. Spear, with a wife and five children, took the danger seriously and claimed that Hargrove's threat caused him to stay away from home for almost two months. Spear decided something had to be done.[14]

At 1:00 a.m. on Sunday, December 18, 1892, Spear and Poker Bill checked into a Fort Worth rooming house located above the Triangle Saloon, just two blocks from Old Man Hargrove's rooming house. Along with their luggage, Spear and Poker Bill carried multiple guns each. They were suspicious of attack and so had their meals delivered to their room and went nowhere except to the saloon below. But their presence was not a secret. They received a number of visitors, including George Hargrove Jr., who, like so many others, came to try and settle the matter on behalf of his father. Spear refused to negotiate. "I'd rather be killed than compromise and be beat out of my money," he said.[15]

Spear had no intention of being killed, however. The following night, Spear left his rooms with a pistol and double-barreled shotgun and walked two blocks with Poker Bill to a vacant field that faced the rear entrance of Hargrove's room at the Atlanta House. Spear squatted down behind a fence and waited for Hargrove to appear. Before he could do much more than get cold, a police officer came upon Spear and arrested him. Spear, irritated, told the officer that if he had waited a few minutes longer the thing would have been all over, meaning that he would have shot Old Man Hargrove.[16] Spear was released within hours after making bail and promising to keep the peace.

The day after his arrest, Spear asked Marshal James Maddox to visit him above the Triangle Saloon. Spear lamented to Maddox about the speed of the police, saying that if it weren't for that, he could have gotten at least two of the Hargroves—probably George and Old Man Hargrove. Spear then sought assurances that if he did shoot the Hargroves, Maddox would have law enforcement look the other way. Maddox refused to agree to that and advised Spear to go to Poker Bill's home in Indian Territory (around Ardmore, Oklahoma) until things settled down. Spear rebuffed the idea. "He said if he went, when he came back he would have the same trouble over again," Maddox recalled.[17]

Publicly, Old Man Hargrove proclaimed that Spear's attempted ambush gave him the perfect justification for killing Spear wherever he found him,

but privately Hargrove was scared. He told a friend that Poker Bill and Spear were too tough for him and that he would leave the area if he got some money together.[18]

On Wednesday, December 21, a mutual acquaintance between Spear and Old Man Hargrove made a last attempt at brokering peace between Hargrove and Spear. Through the intermediary, Hargrove again asked for his $200 and promised to let the matter drop. Again Spear refused and said Hargrove owed him money instead. "God damn him," Hargrove said. "He won't do nothing. I'll take $100 and leave the state."

"Tell Hargrove to look somewhere else for his $100," Spear replied, "for damn if I'll give it. It would not be more than a month before Hargrove would want another $100."[19]

Spear felt he had the upper hand in the dispute because he had uncovered another of Old Man Hargrove's shady deals involving a mortgaged horse belonging to a buggy firm in Fort Worth. Hargrove had mortgaged a horse to the firm and then sold the horse to another party—again selling the horse twice. Spear paid a police officer to go after the horse so that the law could then prosecute Hargrove for selling mortgaged property, but Hargrove was one step ahead.

Old Man Hargrove made a fast deal with two men in Arlington to obtain a promissory note for $110, which would settle the matter with the buggy firm and hold off police action. To get the two men to sign the note, however, Hargrove had to travel to Arlington, and that would put him squarely in Spear's territory. "I told him not to go," Walker said. "If he should happen to meet Spear there, he would kill him or get him in trouble."[20]

But Old Man Hargrove knew he was going to be prosecuted for selling the horse unless he presented a signed note. He had to go but decided to bring sons George and Walker for backup. "He asked me to go to Arlington with him," Walker said. "I told him if he was compelled to go I would go with him, provided he would promise me not to drink any, and to go down on the late train at 4 p.m. and come back on the 7 o'clock train that same evening. He said he would do that and George and myself went with him."[21]

They did not go unarmed. First, Old Man Hargrove went to My Office Saloon and asked the proprietor if he could borrow one of his guns. The bar owner knew about the trouble between Hargrove and Spear and agreed to sell the gun to Hargrove for fifteen dollars. Hargrove gave him ten dollars and promised to give him the rest later.

George and Walker had earlier left two guns at the Ridgeway Saloon. Old Man Hargrove picked up one around 3:00 p.m. and then returned to the

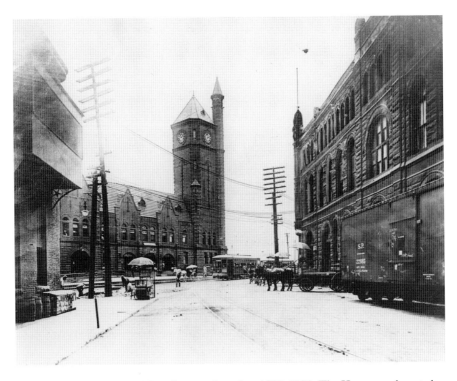

Fort Worth's Texas and Pacific railway station, circa 1900–1903. The Hargroves departed from this station.

saloon almost an hour later with Walker and George. A bartender watched them confer quietly for a moment.

"We won't need it," the bartender heard Walker say.

"I say git it," Hargrove replied.

Walker retrieved a Winchester rifle from the saloon, and he along with his father and brother walked toward Union Depot to catch the 4:10 p.m. train heading east.[22]

Meanwhile, Spear and Poker Bill had decided to clear out for a while and head to East Texas, possibly to take care of some business regarding the court case in Mount Vernon. Spear took $320 cash and had his wife, Martha, drive him to the Arlington depot to take the 4:45 p.m. train to Dallas. They bid each other goodbye, and Martha started back homeward as Spear met Poker Bill in a nearby saloon. Together, Spear and Poker Bill walked to the station to wait for the train coming from Fort Worth.

In Fort Worth, the three Hargroves were preparing to board when they were stopped by station police officer John J. Fulford. Fulford was an

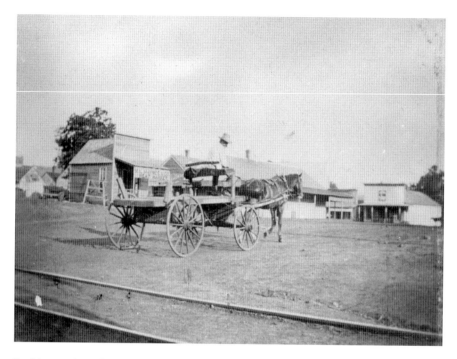

Looking south on Center Street from the Arlington train station, 1896.

intimidating, well-known figure who had been involved with both the bloody labor dispute in 1886 (dubbed the "Battle of Buttermilk Junction") and the shootout that killed gunslinger "Longhaired Jim" Courtright in 1887.

Fulford saw the weapons the Hargroves carried and asked Old Man Hargrove where they were going. When Hargrove told him Arlington, Fulford warned Hargrove not to get into any trouble with Spear. "I don't want any trouble with anybody," Hargrove replied.

"It's no one's damn business what we're going for, so long as we pay our way," put in George.[23] Fulford stood back and watched the Hargroves board the rear car. When the train started moving away, he hurried to the phone to tell Tarrant County sheriff Adam Euless that the Hargroves were headed to Arlington heavily armed.

December 23, 1892, was a mild, clear day, and Harvey Spear and Poker Bill Smith stood on the station platform in the late afternoon light, talking as they waited for the train. When they heard the low whistle, they turned and saw the smoke of the approaching engine. The train stopped with a screech

and hiss of escaping steam. As passengers began to disembark, Spear and Poker Bill walked down the platform steps toward the end of the train.

George headed to the front of the car to get off, followed by Old Man Hargrove. Walker stayed behind to fetch the Winchester from the storage compartment. As Hargrove stepped off the carriage platform, he saw Poker Bill coming toward him.

"Howdy," Poker Bill said.

"Howdy," Hargrove replied.

Poker Bill walked by, and then Spear came through the crowd.

"Howdy, Harve," Hargrove said warily.

"Howdy," Spear replied as he passed.[24]

Hargrove walked forward about ten feet then paused and looked back over his shoulder. He saw Spear, one foot on the steps of the rear car and a hand on the railing, looking at him. Hargrove stared hard at Spear and saw his hand twitch.

"Look out, pa! He's going to shoot!" George cried. Faster than Hargrove could draw, Spear thrust a hand under his vest and pulled out a pistol. Two shots rang out in quick succession.

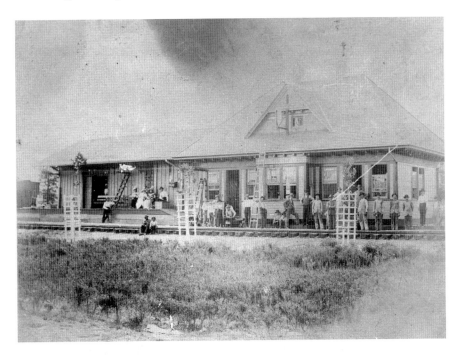

Arlington's Texas and Pacific train depot, the scene of the shootout, circa 1900. A new station opened in 1904.

A bullet shattered Old Man Hargrove's thigh bone, and he fell to the ground. Dragging his gun and ruined leg, he crawled under the train to the opposite side. He tried to sit up, but the pain and damage were too great. He rolled over on his stomach and propped himself on his elbows, sighting under the train for a clear shot at Spear.

Poker Bill fired a shot at George and missed. Walker was still in the coach, and the chaos of the panicked crowd prevented him from getting out. He pushed his way through the crush of people scrambling for safety inside the train and looked out the carriage door in time to see Poker Bill fire at George. When Poker Bill saw Walker, he fired at his head. The bullet brushed Walker's face as it flew over his shoulder.

Walker raised the Winchester and fired once, hitting Poker Bill in the right side of his chest. Poker Bill's pistol fell from his hand as he dropped from the fatal wound. Then he tumbled forward and hit the ground, face first.

Spear, having hit Old Man Hargrove, turned to George and shot him three times in the chest. George fell to the ground, still alive. Spear lunged at George's collapsed body and rained blows on his skull with the butt of his pistol. The pistol grips shattered under the force. George threw up his arm to defend himself while his legs and feet scrabbled on the ground and the life ran out of him.

Walker tried to fire the Winchester at Spear, but the gun jammed. He threw it back on the train platform and began running toward Spear. He drew a pistol with each hand and fired both guns as he charged. Spear turned away from George and got up to fight back, but Walker's bullets found their mark. Spear staggered against the depot platform and fell on it for support. Walker stopped within arm's reach of Spear, pointed the gun at his head and fired. Spear jerked backward off the platform and fell, dead.

Walker didn't stop to check on George or his father. He turned and ran behind the depot and away over a hill while witnesses called for him to stop. Soon, he was out of sight. After Walker fled, Old Man Hargrove, still on his stomach, fired a shot at Spear's body.

"Don't shoot any more," a man called to Hargrove. "Spear is dead."

"God damn him. I thought he was 'possuming and I didn't aim for him to get up again," Hargrove said.[25]

The gun smoke started to clear, and people emerged from inside the depot, under train seats and behind cotton bales stacked on the platform. Men placed Hargrove on a cot and carried him to a nearby doctor's office. Remaining behind were the bodies of Poker Bill, Spear and George. When

the justice of the peace examined Spear's body, he found that Spear had been shot three times in the chest and four times in the head.

News of the shootout traveled to Fort Worth within the hour. As Arlington did not have its own police force in 1892, Sheriff Euless boarded a 6:40 p.m. train to Arlington and took another of Hargrove's sons, Tommy, with him. When they arrived, Euless went directly to Old Man Hargrove.

"Howdy, Mr. Euless," Hargrove said from his cot in the doctor's office. Then he saw Tommy behind the sheriff.

"Howdy, pa," Tommy choked out.

"I'm pretty badly hurt, my boy, but I'll get all right," Hargrove said, clasping hands with his son.

Tears fell from Tommy's eyes. "Where is George?" At this, Old Man Hargrove began to weep.[26] Euless made the decision to take Hargrove back to Fort Worth that night, despite his injury. When the group arrived, a throng of people crowded the train, eager for details of the sensational shooting. Hargrove was carried on a litter to a waiting wagon and carted off to the county jail to face a murder charge. George's body remained in Arlington for the night but was shipped to Fort Worth the next day. Spear and Poker Bill's bodies were taken to Spear's home that night.

Surrounding towns were on the lookout for Walker, but he had immediately returned to Fort Worth and spent the next day hiding at the home of a prostitute in Hell's Half Acre. On Sunday, Christmas Day, Walker sent word to Sheriff Euless that he was ready to surrender.

Walker was savvy enough to know that newspapers would be clamoring for his story. "I wrote out a statement that I want published just as I wrote it and gave it to Sheriff Euless," Walker told reporters at the jail. "He'll give you that paper, and that's all I have to say." The *Fort Worth Gazette* gleefully complied, pointing out to readers that it was reprinted with "literal exactness":

To the editor
I want all who reades this to under stand that I had not tried to shun the Law or Justis; for I no that I havent don any thing to Run from; for I only don what Other man would of did under the circomstancies, but beaing varry tired and worne out from my Long & most teriable down harted walk to the Ft. I thought I would wait a day or 2 before I Surrinderd, but it was my Intention to do so, from the Time I Left Arlington; I came straight To Ft. Worth. I got In Town at 10-30 and went to a quite Plaice to take some Rest as I hav Told you a bove. And The Cause of me Leaving Arlington

was that I were a fraid I would get murderd as my Brother was & I exp
my father the same or as same as murderd from what I can heare; so I will
close hoping Jentle Readers you will Look at bothe sides of the case and
Emagin how you would feel to see a man kill your Brother and down over
him beating him in the face & head with a Pistol. I think you would think
Just as I did, and all so a Father Ling shot & not expected to live; Well
Jentlemen & Ladies I have nothing to feare nor dred nor Regrett.

So I Remain
Yours Resp
Walker Hargrove[27]

After the shooting, Old Man Hargrove lingered in the jail's hospital for two weeks doped up on morphine to ease the excruciating pain in his leg. When it became clear that death was imminent, Walker was permitted to see his father alive one last time. He tried to speak with him, but Hargrove was too weak to respond. After Hargrove's death, Walker was allowed to view the body. When the mortician pulled back the sheet, Walker saw his father's gaunt face and burst into tears, nearly fainting.

Hargrove's wife had been notified of his impending death and subsequent passing, but she and Old Man Hargrove had been estranged for some time and she resolutely stayed away from him and did not attend the funeral. With Old Man Hargrove dead, Walker was the sole survivor of the shootout and was put on trial for the murder of Harvey Spear. He pleaded not guilty by reason of self-defense.

Between two and three hundred spectators crowded in the courtroom to listen to the testimony of dozens of witnesses. Eventually Walker, looking pale and sullen, took the stand and gave his testimony of the gunfight and events leading up to it. When he finished, the county attorney asked, "Walker, who killed Bill Smith?" Walker's attorney objected on the grounds of self-incrimination. Walker was on trial for Spear's death, not Poker Bill's.

"Walker, did not you kill Bill Smith?" the county attorney asked again. Walker's attorney objected that it was immaterial and prejudicial but was overruled. Walker then turned to the judge to make a personal appeal about why he shouldn't have to respond, but the judge ordered him to answer the question.

"I shot Bill Smith with the Winchester. I shot him one time," Walker said. He went on to cite self-defense since Poker Bill fired the shot that whizzed by Walker's face.

Then the county attorney asked, "Walker, have you not been tried for murder in this court before?" Walker's attorney again objected that the question was immaterial to Spear's death and prejudicial but was again overruled.

"I was, and was honorably acquitted," Walker replied.

"Walker, were you not tried and convicted in this court for the murder of Henry Tackett?"

"I was tried and convicted for the murder of Henry Tackett," Walker finally replied. "After I was first tried and convicted the court gave me a new trial, and I was acquitted."

After both sides rested, the twelve-man jury retired for deliberations. "Old Man Hargrove was a bad man," one juror remarked to the others. "Yes," responded another, "and the boys, Walker and George, are bad boys. They are always getting into trouble."[28]

The jury unanimously voted to convict Walker of murder in the second degree. They wrangled a little over the length of the sentence but finally agreed on twenty-five years in the penitentiary. At the verdict, Walker, twenty-three years old, said nothing but gave a low laugh. His mother, who had been beside him during the whole trial, burst into tears.

But Walker never made it to the penitentiary. He returned to the Tarrant County Jail, where he stayed while his lawyers filed an appeal that cited the prosecutor's mentions of the Smith and Tackett murders and of the jurors' conversation about the Hargroves' character.

The appeal was successful, and Walker was retried in January 1895. The new jury returned a verdict of not guilty based on self-defense. Such raucous cheers and applause erupted from the spectators at this that three men were jailed for contempt of court.[29] Walker walked out a free man and was never tried for Poker Bill's death.

With that, the chapter on Arlington's most notorious shootout closed. The town was shedding its boomtown lawlessness. Arlington established its first law enforcement agency in 1894, and the prohibition movement led to the shutdown of many saloons. Train travel decreased in popularity as the electric interurban made hourly runs between Dallas and Fort Worth, with a stop in Arlington beginning in 1902.

While Arlington and Fort Worth continued to grow, Walker continued getting into trouble. In 1900, he killed a man in a bar fight in Bowie, Texas. In 1902, he accidentally killed a hotel worker when his gun discharged and the bullet went through the floor, striking the man below.

Walker and his brother Robert got into a gun battle with a Bowie constable and city marshal in March 1907. After the shooting, the Hargrove brothers fled for Walker's home in Bowie. A mob of eight hundred surrounded the Hargrove house, where Walker's wife, child, sister-in-law and bed-ridden, cancer-stricken mother also lived. The Hargrove brothers refused to surrender. There was talk of burning the house down, but folks respected Walker's mother, and she couldn't be moved.

After an all-night standoff, the sheriff called Walker on the telephone and negotiated the brothers' surrender. A posse of ten deputy sheriffs surrounded Walker and Robert as they were led from the house. Walker was released on bond.

The end came for Walker in May 1908 when he was shot, unsurprisingly, in a Fort Worth saloon. He had been drinking and got into an argument with bartender Walter James over some broken glasses. Walker, thirty-eight years old, started around the bar to settle matters with James, but James pulled a .22-caliber pistol and shot Walker in the head, chest and stomach.

News of Walker's death spread like wildfire, and a crowd of one thousand tried to get into the scene of the crime. "I'm sorry," James said, "but I had to do it."[30] A Fort Worth judge agreed, and James was acquitted. Walker left behind a wife, daughter and infant son, as well as a reputation for being one of Texas's last "bad men."[31]

Arlington Downs

Texas Horse Racing at Its Best

By Leslie A. Wagner

Horses from many of the world's famous racing stables assembled for the Southwest's mammoth turf classic at beautiful Arlington Downs, the Texas Jockey Club's answer to the Southwest's demand for big-time horse-racing. If you've never seen the ponies run…the fast ones…never seen them prance and dance and jockey at the wire…never heard the roar of their hoofs as they streak into the stretch…come and see why they call it the sport of kings![32]
—advertisement for Arlington Downs, 1930

WEALTH AND INFLUENCE BRING ARLINGTON DOWNS TO LIFE

It took a wealthy and powerful man, William Thomas Waggoner, to build the fabulous racetrack Arlington Downs. As a driving force, he swayed public and political interest in horse breeding and racing enough that parimutuel betting on horse racing was legalized after he had already built his racing plant. It cannot be determined whether Waggoner directly affected the public's enthusiasm for horse racing at the Downs with his own zeal and public image, but after his death, cultural, economic and political influences turned against horse racing and gambling, bringing the era of big-time horse racing to a close in Texas. In its heyday, however, Arlington Downs was the place to be and be seen. A day at the races was fashionable and exciting.

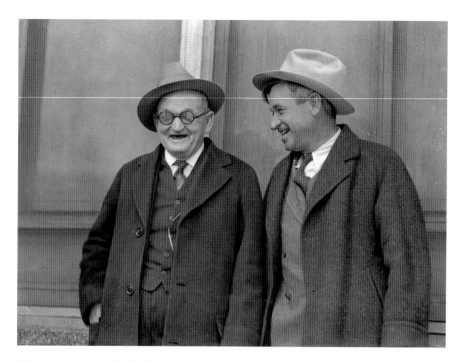

Will Rogers, *right*, and W.T. Waggoner at opening day of Arlington Downs, October 19, 1933—the first season that parimutuel betting was legal in Texas.

THE FOUNDING OF ARLINGTON DOWNS: W.T. WAGGONER'S "HOBBY"

Arlington Downs was casually referred to as the "hobby of an old-time cattleman." W.T. Waggoner's money—a result of ranching and oil—was spent freely to encourage the breeding of fine Thoroughbred race horses in Texas.[33]

Horse racing had long been a popular pastime in Texas. There were racetracks, precursors to Arlington Downs, in Electra (a town named after Waggoner's daughter) and the Decatur area, all within range of Waggoner's ranch. In 1895, Waggoner bought his first racing stallion, Stride Away, and established a small breeding farm on the southern edge of his ranch near Electra, then known as Beaver Switch, in northern Wichita County. For nearly three decades, the stock farm thrived, and its horses toured the country's largest racetracks, reaping honor after honor. Then fire swept the stables of the farm at Electra, and many fine Thoroughbreds perished. Waggoner was "heartbroken, but undaunted" by the tragedy.[34]

ACQUISITION OF THE THREE D STOCK FARM

Deciding to seek a ranch location closer to his Fort Worth home, Waggoner purchased 696 acres of land near Arlington on the Fort Worth–Dallas turnpike. This initial purchase composed the heart of the Three D's stock farms, and subsequent purchases more than doubled this acreage. The nucleus for his track was thus established on 3,000 acres east of Arlington.

Every object on the estate was painted blue and white—the colors under which Waggoner raced.[35] High blue and white fencing surrounded the property, installed by a workforce of about one hundred men.[36] For the protection of his stock, the fence had rounded corners to prevent animals from becoming "caught and injured." The farm was served by a 925-foot-deep artesian well from which electric pumps forced water into a tall blue and white 100,000-gallon tank.[37] Chinese elm trees planted every 20 feet lined the outside borders.[38] Since operations had begun in October 1927, two large stables and several smaller ones had been built, along with three brick houses for the managers and trainers.

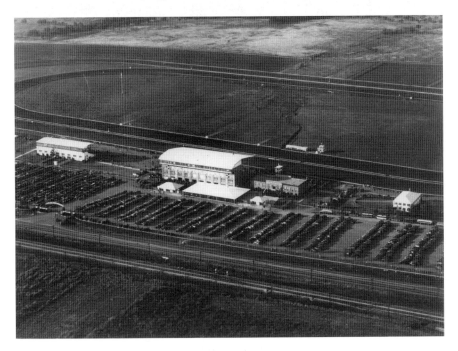

Aerial of Arlington Downs racetrack, circa 1929–30. The track was located roughly northwest of the modern-day intersection of Highway 360 and Division Street.

The curved racetrack was central to the property. A large iron grandstand that accommodated one thousand people was "built for the benefit of the capitalist and his friends." In addition, there was a wide dirt "straight shoot" that stretched perfectly level for three-quarters of a mile, used for trying out two-year-olds.[39]

His "sole aim in establishing [the] farm was for the better breeding of thoroughbred horses and for the training of his privately owned stock."[40] It was described as the "realization of a rich man's dream, an institution he [had] visioned for a score of years. And there [was] still another and perhaps…greater urge behind the project—a man's love for horses, a hobby that [knew] no bounds."[41]

His intention to "breed the finest racers on the turf and his investment of nearly $2 million in the Arlington farm is indeed convincing proof of his unbounded faith in this section. Climate, soil and water are elements of serious consideration in maintaining perfect health of thoroughbred horses and these are happily combined here, as evidenced by the Three D's fine racers."[42] In essence, Waggoner wanted "to prove to the world that Texas had few equals and no superiors in the development and means of breeding and raising thoroughbred horses and cattle."[43]

STATE FEDERATION OF WOMEN'S CLUBS

Even before the first season officially opened in 1929, Waggoner gave demonstration races at the Downs. Three races were run on April 22, 1929, at the Three D Farms for "the entertainment of the ladies of the State Federation of Women's Clubs. The public was invited and it is estimated that 6,000 were present. Almost all Arlington business houses were closed from 4 to 6 p.m. and the town went out and were guests of Col. Waggoner on this, the first opportunity given to the public to witness races and see the world's finest horses demonstrate their speed."[44]

Waggoner did not depend on the lure of the races alone. He included much fanfare and gracious hospitality in many events. The April 22 races were preceded with "a parade, perhaps two miles in length, formed at the well in the heart of the business section, and was led by uniformed traffic officers and the band of the North Texas Agricultural College and cadets who rode in large busses furnished through the courtesy of Col. Waggoner, and under the direction of [Arlington] Mayor [William] Hiett. Upon the

arrival at the grandstand, the Federated Club women were given box seats and made to feel at home by the Mayor."[45]

THE TEXAS JOCKEY CLUB

The Texas Jockey Club was formed in the spring of 1929 to set the dates for the inaugural meet. The officers of the Texas Jockey Club were W.T. Waggoner, president; his son Guy Waggoner, vice-president; and his other son, Paul Waggoner, secretary-treasurer.[46] They decided on a fifteen-day meet in October so that the timing and location of the inaugural races fit neatly into the racing schedule between the thirteen-day meet at the State Fair of Texas and the Thanksgiving Day opening in New Orleans.[47]

But the dates for Arlington Downs changed with the destruction of the State Fair of Texas Park track to make way for a football stadium (the Cotton Bowl). The new dates for the season were November 6–16, 1929.

OPPOSITION

There were some who opposed the track. State Senator Julien C. Hyer addressed the Woman's Christian Temperance Union of the Twelfth Congressional District at Weatherford Street Methodist Church in 1929. He told those present that it was likely Arlington Downs would become "one of the greatest racing centers in the country and a hotbed for law violations. The stage is set, although officials and backers of the project have been careful not to violate any statutes so far." He implied that local citizens would forget their stand once thousands of people spent their money with local merchants and yield to the temptation of letting the racing center have "full leash" to include legalized betting on the races. Mrs. J.T. Bloodworth, the organization's president, voiced a similar opinion, denouncing the racetrack's location in this vicinity because "liquor, betting and prostitution invariably follow horse racing, no matter in what way it is conducted."[48]

FORT WORTH ASSOCIATION OF COMMERCE

Despite the naysayers, W.T. Waggoner was much revered by the business community. The Fort Worth Association of Commerce honored him on October 22, 1929, at a Three D Stock Farm "barbecue and private showing of many fine horses…as a testimonial to…W.T. Waggoner and his sons by the Fort Worth Association of Commerce."[49] Will Rogers was among the notables present.[50]

Dr. C.C. Selceman, president of Southern Methodist University, voiced the "spirit of the occasion" by congratulating the Southwest for a citizen such as Waggoner who has set "the approaching races upon a very high plane [which] will give great pleasure to the many and do harm to none."[51]

Also in attendance was Dallas mayor J. "Waddy" Tate, who closed his remarks with the statement, "If I were Governor of Texas, I would encourage horse racing 365 days out of every year!" This sentiment brought cheers from the gathering.[52]

OPENING DAY

Waggoner's track, built at a cost of more than $2 million, was described as the "last word" in modern racetrack construction.[53] The facility boasted six hundred horse stalls with oak paneling and padded cement floors,[54] grandstand seating for sixteen thousand, 151 viewing boxes, a loudspeaker system for announcing the races and a "sumptuous" clubhouse.

There is ample space for entertaining in the clubhouse, which has on the main floor a spacious lounge, a ladies' lounge, a smoking room and a dining room that has a seating capacity of 125. The lounge, finished with stained paneled walls and beamed ceilings, is attractively furnished with divans and easy chairs done in warm red tones. The ladies' lounge is done in blue and green tones, the draperies being of blue print and the furniture upholstery in blue and green German madras. There is maid service; they go as far as to wipe the sand from high heels that have ground into the gravel.[55]

The opening of the track made national news, and visitors from across North America were expected to arrive. Arlington businessmen gave money generously so that the city was decorated in grand style for the meet, with "red white and blue flags, bunting, ovals and welcome signs…flung across the streets and…the fronts of the business houses."[56]

"Arlington is all set for the races!" proclaimed one article in the *Arlington Journal*.

> Cars…from every section of the United States…have brought people here interested in the Arlington Downs races…[that will run] Nov. 6…until the 16th. Race-wise and foresighted fans are attempting to find rooms in the city…but are even now having a mighty hard time of it. Telephone calls are pouring in from Texas towns and distant states asking about lodging. Mayor Hiett has answered letters from some of the nation's most celebrated men as well as…a host of unknowns…[inquiring about] the races.
>
> Strangers have already begun to crowd eating houses in Arlington and each day brings new faces.…This places a heavy burden upon the transportation companies. The North Texas Traction Company announced that the interurban limited cars will be stopped here. Large buses will meet all interurbans and carry the passengers directly to the tracks. Traffic congestion on the highway is expected.…Arlington people are asked to refrain from going to the races in their private cars.[57]

Many local residents walked to the races to avoid traffic jams.

On a cold, wet Wednesday afternoon, nine thousand people came to Arlington Downs to watch the races on opening day. The *Arlington Journal* reported, "Celebrated horses as well as the nation's celebrated men were present, and saw a corking good afternoon's entertainment."[58]

The success of Arlington Downs, to some extent, can be attributed to W.T. Waggoner himself. People may have found themselves lured by his millionaire image and his perceived generosity in that he provided entertainment, employment and economic opportunity to the greater Metroplex area. News coverage of upcoming racing events frequently referred to "W.T. Waggoner, millionaire owner of the Three D's racing stable" or other dazzling terms denoting his wealth. He certainly provided ample financial backing and demonstrated excellent public relations.

The manner in which the citizens of the Lone Star State turned out for the opening day brought smiles to W.T. Waggoner as he strolled at intervals between the secretary's building and clubhouse. Waggoner settled down in a box in the northeast corner of the grandstand and leaned close to the rail in an attempt to get a glimpse of the races through aging eyes. He chuckled. When the crowd passed the nine-thousand mark despite intermittent gusts of rain, Waggoner said he had his money's worth.[59]

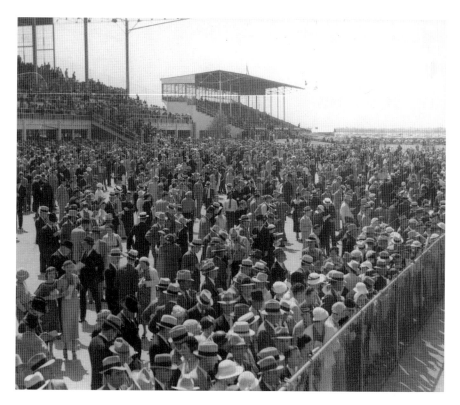

Crowds at Arlington Downs, circa 1934–36.

THE CREAM OF SOCIETY

Ladies who attended the races took great care to dress properly. The *Fort Worth Star-Telegram* society page featured a photo spread titled "Snapped at Arlington Downs" showing a woman "fashionably attired in black coat with deep shawl collar of fur" and another who wore "a fur-trimmed coat of brown, with hat of the same shade."[60]

The track featured prominently in the 1929 debutante season. Mrs. E.P. Waggoner and Mrs. Guy Waggoner hosted a luncheon at the Texas Jockey Club at Arlington Downs for debutantes of both Fort Worth and Dallas. Decorations for the luncheon, which were described as some of the most attractive seen that week,[61] carried the racing theme and included the blue and white colors of the Three D. All the debutantes attended the races after the luncheon. Among the debutante family names recognizable to us today were those of Van Zandt, Meacham, Stemmons and Cox.[62]

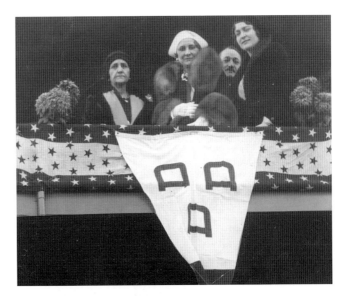

Waggoner family members behind Three D bunting, circa 1930s.

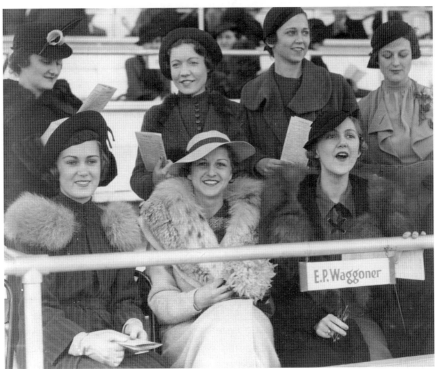

Debutantes at Arlington Downs races, November 25, 1935.

The meet was extended by one day to run six races supporting the Community Chests charity funds of Dallas and Fort Worth. Three of the events were named for the mayors of Arlington, Fort Worth and Dallas: William Hiett, William Bryce and "the man who rules the destiny of Dallas,"[63] J. "Waddy" Tate. Tate, however, did not see the race named for him.

Tate, mayor of Dallas, did not see the races at Arlington Downs because Frank Goodwin, the gateman, refused to let him in on a pass. Monday was benefit day for the Community Chests at Arlington, Fort Worth and Dallas. Half of the gross receipts were given to the poor of these cities. Every man, woman and child who went through the turnstiles, with the exception of the jockeys, paid the admission price right on the barrelhead. That included W.T. Waggoner, his sons and everyone connected with the business. Tate was stopped at the gate and told that he would have to pay. "Why, I'm Mayor Tate of Dallas," he said. "I don't have to pay." "I don't care if you're Herbert Hoover from Washington, you'll have to shell out if you see the ponies trot," Goodwin replied. Tate left. A few minutes later, the J. Waddy Tate Handicap was run on the track.[64]

THE ADVERTISEMENTS

After the 1929 inaugural meet, booster advertisements congratulated Waggoner on the success of Arlington Downs. An ad placed by Arlington Lumber Company read: "When it comes to building, Mr. Waggoner and his sons have shown that they are in first place. Arlington, too, is a winner in having the great Arlington Downs built right at our door. We are pleased to have had a part in helping to build this wonderful institution, and stand ready with our services in the future. Our Builders Supplies Were Used in Building Arlington Downs."[65]

The sentiment expressed by the Continental National Bank of Fort Worth was, "Arlington Downs—a monument to W.T. Waggoner—a contribution to our State, County and City."[66]

Fort Worth Steel and Machinery Company's ad read, "Congratulations to W.T. Waggoner and Sons. The wholehearted approval of the people of Texas is placed upon this $2,000,000 institution as is attested by the fact that hundreds of thousands are their guests."[67]

Waggoner was delighted with the response to Arlington Downs' first season. He had brought the thrills of racing to the public, and they loved it—and that brought him pleasure.

CONSTRUCTION OF ARLINGTON DOWNS

Waggoner's first efforts—the track, grandstand and stables—were based on his belief that competition was the only proper way to stimulate breeding. The idea grew, however, as they prepared for the second annual races. His son, Paul, visited the larger tracks in the country to "learn how they were conducted, their appointments and their outlay." When Paul returned, workmen were sent to the farm. The track was expanded, more seating space was built, paddocks and visiting stables were constructed to the south of the track and the large Three D training stable erected on a hill overlooking the farm.[68] "In its development [it became] known throughout the world as the finest privately owned track in existence."[69]

Arlington Downs and the Three D stock farms were, by far, the largest and some of the finest in America. It had large fireproof stables and a twelve-mile system of roads. A polo field was constructed, and polo ponies were also trained there. The farm was beautified by shrubbery and two lakes (one located in the center of the track). Waggoner also had excellent dairy cattle and poultry on the farm. He employed some sixty men in the various departments on the farm, from jockeys to dairy experts.[70]

As part of Waggoner's continued improvements, which showed consideration for horse racing fans, he had the lower section of the big grandstand enclosed with huge glassed-in doors. "Bitter winds may blow and it may pour torrents, but spectators at Arlington Downs races this year will be inconvenienced by neither." Heating equipment was installed in the enclosure to keep the place warm should the weather get too cold for comfortable grandstand sitting. The enclosure was roomy enough to comfortably house several thousand people. A lunchroom for light meal service was added so that visitors to the track could "take care of their gastronomic needs without sacrificing sight of the daily races." Loudspeakers were also included in the glassed-in section. "The features of every event [were] announced through these speakers and a racing expert [was] on the microphone during the races to follow the horses around the track."[71]

THE SECOND ANNUAL SEASON

"The Waggoners [were] undecided throughout the year whether to continue the annual event started in 1929 and it was not until [October 2] that the

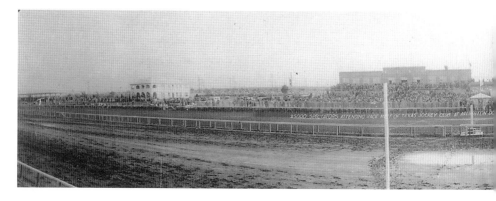

Panorama of Arlington Downs racetrack, 1929.

decision was reached."[72] Arlington made "extensive preparations…for the reception of visitors from all parts of the Nation who will witness the Annual Racing Program and Live Stock exhibit…Nov. 1 to 11, 1930." The Dallas–Fort Worth area looked forward to the "exceptional affair…with considerable pride and untold pleasure."[73]

"Thousands of distinguished guests will spend three days here, aside from the great throngs who visit the grounds daily with a view of enjoying the unusual event….The exhibition of thoroughbred live stock will attract all lovers of high-class animals. The occasion will be a general picnic and celebration for the entire citizenship."[74]

Advertising in the *Dallas Morning News* for the upcoming races at Arlington Downs gave the following pertinent information: general admission was $1.00. Jockey Club Membership was $27.50, which admitted a couple to the entire meet. Tickets were sold at the Adolphus Hotel and Baker Hotel. There were six races daily that began at 2:00 p.m. No races were held on Sunday. The Downs could be reached by auto on the Dallas–Fort Worth pike, by the interurban with motorcoaches to and from the Downs or by bus from Lamar and Commerce.[75]

The entire North Texas Agriculture College (NTAC) faculty, student body and others connected with the college were invited as guests to opening day on November 1, 1930. In honor of the invitations, all male students paraded from the college campus, and the girls joined in the parade at the Downs.

The parade order was detailed in the *Arlington Journal*. The parade began at Main and Center Streets with a motorcycle escort preceding W.T. Waggoner in a car, followed by NTAC dean E.E. Davis in a car. The NTAC band came next in trucks and then the NTAC cadet corps. The American

Legion followed, and then the NTAC Cooperative and Special Students came four abreast. Private automobiles enlisted to carry NTAC girls and other interested citizens brought up the rear.[76] Once the parade reached the Downs, the NTAC band and cadet corps gave a dramatic performance of "The Star-Spangled Banner."[77]

The crowd of more than ten thousand at the opening of second annual racing meet at Arlington Downs was particularly noted for its stylish dress: "The event was…a magnificent fashion revue, a splendorous gathering of society, and a bright mark on the social calendar."[78]

A group of Dallas and Fort Worth social leaders expected to serve about one hundred at a luncheon in the Texas Jockey Club rooms for the benefit of the projected Texas Children's Hospital. About three hundred persons came, however. Future debutantes in dainty aprons served the food until it was gone.[79] In her *Fort Worth Star-Telegram* article, Bess Stephenson commented, "The races satisfy such a universal longing for drama, smart gay crowds, sports, social splendor, and the show of thoroughbreds galloping over the tracks that ever increasing crowds are expected to visit the Downs. When women can don their chicest costumes and literally show them to thousands and when men…can find excuse for buying gay, checked suits and wearing them with swagger, races are likely to prove popular."[80]

THE EFFECTS OF PARIMUTUEL WAGERING LEGISLATION

While gambling on horse races was not a goal of Waggoner, some articles suggested that he would support legalization because it would encourage fine Thoroughbred breeding in Texas. An April 1929 *Arlington Journal*

article stated that W.T. Waggoner is "determined to create sentiment in this state in favor of legalizing parimutuel wagering on horse racing and to revive interest throughout Texas in the 'Sport of Kings.'"[81] Behind the scenes, though, Waggoner aggressively lobbied Texas lawmakers to legalize parimutuel wagers.

But while betting remained illegal, the statement, "Texas laws against betting will be strictly enforced," appeared with each advertisement placed by the Texas Jockey Club.[82] "Sheriff [Red] Wright announced…he will exercise vigilance…to see…there is no gambling or other law violations at the horse races." Each ticket and pass issued by the management was printed with a statement of caution against gambling and drinking intoxicating liquors at the races.[83] Before the opening meet in November 1929, track officials trained an army of track attendants in their duties. Many of the attendants were special track policemen garbed in bright blue uniforms trimmed in white and red.[84]

> *It had been the boast of Arlington Downs that for eleven days in 1929 a betless race track was maintained and that record was intact….It was a race track and a race meet at which the prohibition laws were honored with obedience.*
>
> *Texas Rangers, uniformed policemen from Fort Worth and plain-clothes officers from the Metroplex mingled with the crowd…[but] had little to do for the crowd was in the mood to respect law and…Waggoner's plea for obedience.[85]*

Fifteen Dallas hotels sent a telegram in February 1929 to Senator Thomas B. Love of Dallas expressing their support of a bill providing for operation of parimutuel machines in Texas.[86] A group of Dallas ministers sent a telegram expressing their support of Senator Love's opposition to the bill.[87] Those involved with Arlington Downs were anxious that a bill be passed, but they felt the best way to create public sentiment for such a bill was to begin racing and then seek legal protection. It had already been done in Miami, and a bill was "almost a certainty" in Florida. The Waggoner interests were "working on the same theory."[88]

However, "Waggoner's proposal to stage a meet in a state which did not allow open wagering, his offer to guarantee seven races a day, no purse less than $1,000 and to provide a Texas derby with $150,000 added money, [was] perhaps unparalleled in the history of thoroughbred racing."[89] Waggoner's singular dedication to his cause—the advancement of fine Thoroughbred horses in Texas through racing—was unique.

The gist of correspondence between District Attorney R.A. Stuart and W.T. Waggoner regarding gambling was printed in a November 9, 1929 article in the *Arlington Journal*. The position of racing officials and District Attorney Stuart against gambling at Arlington Downs was made plain. "Rigid enforcement" of the state laws in reference to gambling in any form was promised by both Waggoner and Stuart. Waggoner's letter gave details of his enforcement plan and declared that anyone involved would be "ejected from the grounds." Waggoner desired "clean sportsmanship" and further stated:

> *My chief purpose is to encourage and to bring about, if possible, the raising in Texas of fine horses, and to restore in Texas that great industry. It is acknowledged by horse breeders in all the state that the grass, soil and climate of Texas produce the greatest horses in the world. Among the best and fastest horses that have raced in the North and East are horses bred and raised by Texas people…in the great state of Texas, and among these are included some bred and raised by me on my ranch in Wichita and Wilbarger counties.*[90]

Waggoner went on in his letter to express concern over illegal bookmaking beyond his control:

> *There has been some rumor that as a result of the conducting of these races there will be pool-selling and bookmaking in the cities of Fort Worth and Dallas. I hope this will not occur and I shall be glad to join in any effort to prevent this if there should be any basis for this feeling. On every ticket through which admission is had to these races, is the agreement of the holder that he will faithfully observe and will not violate these laws, and the further agreement that if he does, he consents to being expelled from the grounds.*[91]

District Attorney Stuart responded:

> *The Texas statutes on this subject…cover every phase and prescribe very severe penalties. They are punishable by fines from $25 to $500 and imprisonment in jail from 30 to 90 days. A more far-reaching statute, however, makes it the duty of the District Attorney to close by injunction proceedings any premises used for betting, book-making, buying or selling of pools, or any premises where such is even permitted. Under this statute,*

it will be the duty of this office to close [even]*…your magnificent Downs in Arlington,…or any other place where these violations occur.…Any knowledge or acquiescence on* [your part]*…in permitting gambling or other law violations will subject you and your place to the provisions of these laws.*[92]

THE TEST CASE OF THE OPTION BETTING SYSTEM

In 1931, Waggoner brought in John Murphy of Chicago to help him set up an arrest for betting that would serve as a test case in the courts. They recruited Arlington druggist P.L. Coulter and Vernon, Texas attorney O.O. Franklin to be "arrested" by Sheriff James "Red" Wright for placing bets on the races. Waggoner promised to pay all fees if the men were convicted.

On September 19, 1931, Sheriff Wright "strolled into the option ticket office, saw several hundred persons wedged in and about the ticket counter, and a fair amount of money changing hands. He laid his hand on Coulter and Franklin and informed them they were under arrest."[93] Sheriff Wright took some notes and then took the two men outside, where they posed, smiling for photographers. Afterward, they returned to the track to watch the third race.

Judge Barwise, a Fort Worth attorney, represented Coulter and Franklin. The two were convicted and fined twenty-five dollars. The case was

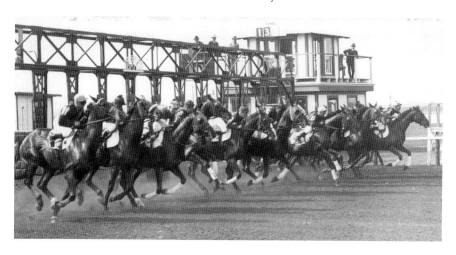

Horses breaking from the gate at Arlington Downs, circa 1930–36.

then appealed to test the legality of the "option betting plan." They lost the appeal. Waggoner, however, won the war. In 1933, Texas legalized parimutuel betting.

PASSAGE OF PARIMUTUEL LEGISLATION

It was a banner day for Arlington after the racing bill passed the state legislature in 1933. "The shriek of the fire siren and the blast of car horns announced [the senate passage of the race horse rider] to the people of Arlington."[94] The House passed the bill by a majority of almost two to one.

In an address before the Rotary Club, Sheriff Red Wright told his audience that Arlington and Tarrant County would be proud of the immediate improvements planned for Arlington Downs. The plant was expected to be enlarged, but details were not announced. It was also rumored that a big hotel was to be erected in the center of Arlington "that [would] be second to none in the South...certainly a big boom to the town and sure [to] attract patronage from nearby cities."[95]

On the adoption of legalized race horse betting, State Representative J.C. Duvall said, "Four thousand men, which means a livelihood for perhaps 12,000 persons, will be given work almost immediately...[upon the legalization of] race horse betting....I know that preparations are being made to open race courses and downs at San Antonio, Houston, El Paso and perhaps at Beaumont."[96]

Arlington mayor William Hiett announced that the Waggoner interests expected to put two hundred men at work with many more jobs to follow. In addition, the purchase of at least fifty thousand bushels of oats was anticipated from farmers in the Arlington vicinity.

> *I know that...plans for improvement of the racing plant call for the expenditure of $1,000,000....And the most beautiful park in the South will be built. We are expecting to establish an extensive industry that will benefit many lines, and the betting feature is the smallest problem in this move. We are ready to go into horse breeding and feed raising, and employ many men, making permanent improvements at Arlington, which will be of benefit to the entire State. This will give the horse a chance to come back in the machine age at a time when machines are looked upon as one of the causes of the depression.[97]*

The legalization of parimutuel betting took effect ninety days after Governor M.A. Ferguson signed it into law.[98] The appropriations bill passed that year created the Texas Racing Commission, effective December 31, 1934, and allotted a total budget of $1,260 to pay its operating expenses. Guy L. Waggoner, W.T. Waggoner's son, was nominated chairman in January 1935 and was confirmed to that position on February 6, 1935.[99]

ILLEGAL WAGERING: THE BOOKIE

Even after the legalization of parimutuel betting, bookmaking—making bets elsewhere other than at the racetrack window—was still illegal. To prove the point that "bookmakers were operating within the shadow of the Capitol's dome," State Representative Henry C. Kyle placed a bet on a horse race with an Austin bookie. Kyle won $22.90 and pledged to "use his winnings…to buy the Travis County District Attorney a new pair of glasses and an ear trumpet.[100]

In an attempt to curtail illegal bookmaking, the Texas Racing Commission, in a special session, passed a strict rule restraining any track from allowing telephones, wires, radio or other communication that might be used by bookmakers to obtain information on races at licensed tracks. It was not meant to interfere with racing news by legitimate newspapers but denied them of "morning scratches" that might aid bookmakers.[101]

THE 1934 SEASON FOLLOWING PARIMUTUEL LEGALIZATION

Excitement for race season was high after the legalization of parimutuel betting. One article in the October 26, 1934 *Arlington Journal* described the city's anticipation:

> *Cars, long, racy looking models with out-of-state licenses, little men they call jockeys, the latest of fall clothes on all of Arlington's popular set, hurry and bustle just about two o'clock, people moving into their own back yards, strangers living in one's neighbor's house—when all this comes to pass, Arlington knows its Arlington Downs and its group of fast-moving races that have come to town.*

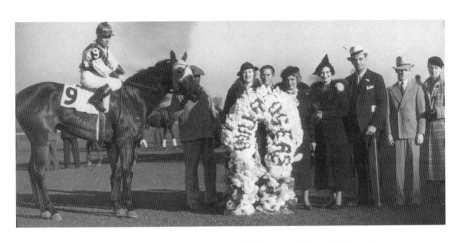

Johnny Longden on Blackbirder, winner of the Will Rogers Memorial Handicap at Arlington Downs, November 21, 1935.

Telephone calls made in the afternoon hours usually draw a blank—or a maid's voice saying, "Sorry, but Mrs. Blank and everyone else in the family have gone to the races." And that's that.

For more than three weeks each Spring and Fall all Arlington takes on the "bunting and flag" atmosphere. Everyone is on the alert; it's not fashionable to be caught at home. Afternoons on the downtown streets look as if Sunday had come again in the middle of the week. But a little after five, the rush begins again. Try to get across the highway with a triple line of cars headed home to Fort Worth or Dallas.

Advice to those who either haven't caught the fever yet or are tied down to businesses or homes: if you want to find Mrs. Jones or Mr. Smith at her home or at his business, make it a morning call—that is, if you can get them away from the dope sheet![102]

More eager than ever, Arlington Downs prepared for the 1934 season of races with renewed enthusiasm: "Arlington Downs is ready! The infield has been sown with winter grass, and flowers have been planted in star-shaped formation about the flagpoles. The grandstand and clubhouse have likewise been further beautified, with recent rains transforming the running strip into a satiny smooth surface that will insure fast time from the very start....The dream of W.T. Waggoner for a track that will rival any in the country for sheer beauty has come true."[103]

W.T. WAGGONER DIES

Waggoner didn't have long to enjoy his victory. He died following a second stroke of paralysis in a Fort Worth hospital on December 12, 1934. In his obituary, the *Arlington Journal* lamented: "Arlington will miss [him] in many ways. He can be named as one of the greatest contributors to Arlington's development and prosperity. It has been stated that he built Arlington Downs, not with individual profit in mind, but with the idea that he was bringing back to Texas the real love of blue-blooded horses, which he himself had."[104]

At the November 11, 1935 races, instead of the "Eyes of Texas" being played before the running of the Waggoner Memorial Handicap (previously named the Waggoner Handicap before his death), a memorial taps was played.[105]

GOVERNOR ALLRED'S PUSH TO MAKE PARIMUTUEL BETTING ILLEGAL

Parimutuel betting lost its champion with Waggoner's death, and Governor James P. Allred began efforts to repeal it. Knowing its repeal would be ruinous to Arlington Downs, Arlington citizens made frequent trips to Austin to lobby in favor of the law. The March 26, 1937 issue of the *Arlington Journal* reported that "a large delegation of business men from Fort Worth, Dallas and Arlington [went to]…Austin for a hearing before the Senate Committee on the bill repealing betting on races in Texas. A large number of cattlemen from all parts of Texas who are opposed to repeal…[were] also in Austin.… Businessmen in favor of the races have made several trips to Austin to lend their assistance."[106]

Governor Allred, however, had a different view. In his January 28, 1937 message to the Senate, he said:

Since the summer of 1933 an unparalleled wave and mania for gambling has swept over the State. Legalized gambling has given spread to even wider illegal gambling. Bookie shops, gambling houses, slot and marble machines and almost every other form of gambling has flagrantly flourished…

It is interesting to note that most of these conditions have arisen, indeed have flourished, since the passage of the race track gambling law. Book making, particularly assumed gigantic proportions after this law

was passed. The stimulating effect created by actual race meets held in the State encouraged housewives, clerks, employees, business men and even public officials themselves "to play the ponies" on races run hundreds of miles away.

Undesirables have come to our state—race track touts, pickpockets, confidence men. Horses have been doped. Crooked races have been run. Bets have been paid off by bookie shops on races before they were even run.

Most of us, of course, like good clean sport. Most of us enjoy a clean horse race, but, regardless of how we feel about it, down in our hearts we know that the average person doesn't have a chance. He is bucking an unbeatable game.

In my message to the Legislature two years ago I quoted denunciations of gambling by George Washington, Franklin, Blackstone, Shakespeare and the Holy Bible. Since that time, such modernists as Arthur Brisbane and O.O. McIntyre have joined the procession. Brisbane said that it is possible to cure a drug addict or a liquor sot, but impossible to cure a gambler; and McIntyre said that of all the gambling evils, "playing the ponies" is the worst.

Without doubt, race track gambling has had a bad effect upon business. Housewives have spent their allowances, bank clerks and employees have absconded with funds, men who formerly took pride in the fact that their credit rating was good, have become dead beats. These are not isolated cases. They are and will continue to be general.

Twice now repeal of the race track gambling law has been an issue in the Governor's race. In both instances the candidate favoring repeal has been elected Governor. Twice now repeal of the race track gambling law has been a clear cut issue and a platform demand.

Two years ago it wasn't even voted upon. In all fairness, members of the Legislature, I ask you, are we not entitled to a clear cut vote on this proposition?...Let's dispose on it one way or the other.[107]

On March, 31, 1937, Governor Allred again sent a message to the Senate in which he discussed the indictment of an owner of a string of race horses operating in California, New York and Texas. Upon his arrest, a startling condition was unveiled by federal officers concerning a narcotic ring that had been operating throughout the country, with its headquarters in Texas.

Allred brought up other drug activity related to racetracks in Texas, from a trainer of race horses at Alamo Downs who was an addict at the time of his arrest to numerous narcotic cases that had been developed at racetracks in

other parts of the United States as well as Texas. Some involved the doping of race horses, and others involved peddlers dealing with addicts usually found following the races from city to city.

Allred established the connection of narcotics with the racetrack, from the "cruel doping" of horses to the presence of narcotics at the tracks, and extended the threat as "a menace to the welfare of our entire citizenship, particularly the children. I am informed that the traffic in marihuana is constantly growing; that it is being furnished to school children." He indicated that present Texas law was inadequate to cope with the situation and pleaded with the legislature to act swiftly.[108]

Governor Allred finally called a special session of the Forty-Fifth Legislature to drive home his wishes: no more gambling on horses.[109] In his address to the Senate, he called "to outlaw and prohibit the so-called parimutuel betting or gaming on horse races, at race tracks, legalized by the Acts of the Forty-third Legislature in 1933."[110]

Two senators voted no, citing "the vast investments made by in race tracks and equipment since the legalization of gambling."[111] But Governor Allred was dissatisfied with any reason to allow continued parimutuel betting on horse racing. He signed SB No. 1, making parimutuel betting once again illegal on May 27, 1937, in the First Called Session of the Forty-Fifth Legislature.[112]

ARLINGTON DOWNS AFTER ITS PRIME

In July 1937, Arlington Downs was dismantled as a racing plant, and most of the Thoroughbred horses were sold. About fifty men were put out of work, and the owners, Paul and Guy Waggoner, declared a loss of approximately $1 million. All other business interests of the Waggoners were also up for sale.[113] Other uses were found for Arlington Downs in the following years. "Horses' hooves [pounded] the track once more…without benefit of daily doubles," as part of the entertainment at the Tarrant County Fair, held in September 1939. Use of the racetrack was donated by Paul Waggoner.

During World War II, Arlington Downs served as a motor pool. Mechanics tested the amphibians in one of the small lakes on the Waggoner property. The interior of the grandstand hummed with the servicing of motors. The parking behind the gates held everything from jeeps to ten-ton trucks. The

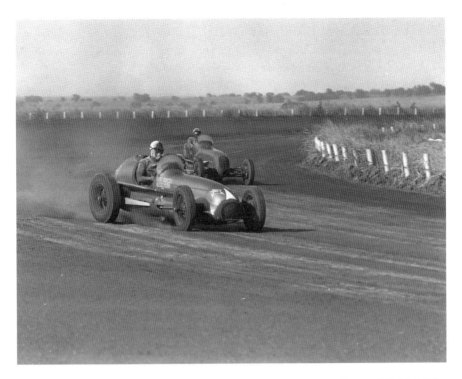

Troy Ruttman making a turn in the Blue Crown Special at Arlington Downs, July 16, 1949. Trailing him is Lee Wallard.

convenience of good highway and train facilities made the Downs an ideal motor pool location.[114]

The First Annual Three D Rodeo at Arlington opened to a sell-out crowd in September 1945. Guy Waggoner said, "The plant is ideal for the shows, and we plan to give Texas some of the best western entertainment it has ever seen."[115] The Third Annual Arlington Downs Rodeo in late summer 1947 received the gate receipts toward the purchase of five acres of farmland, Optimist Acres, for the Future Farmers of America. The events were preceded by an opening day parade.[116]

In 1947 and 1948, Arlington Downs was used for big car AAA-sponsored racing one-hundred-mile national championship races.[117] And in November 1951, General Motors leased thirty-six thousand square feet on the ground floor of the grandstand to store equipment that arrived before the groundbreaking of its Arlington plant in 1952.[118]

DEMISE OF THE DOWNS

On November 16, 1953, the clubhouse, secretary's building and two polo barns were demolished. On July 13, 1957, the Morrow Wrecking Company was put under contract with the Great Southwest Corporation, which purchased the property for approximately $6 million. The grandstands were razed to make way for industrial development in the area.[119] The Arlington Downs Tower now stands at the northern end of the Three D Stock Farm lands, named for the racetrack. On May 31, 1978, a historical marker was erected there and dedicated in memory of W.T. Waggoner and his sons Guy and Paul.[120]

To say that W.T. Waggoner built the Arlington Downs racing plant for financial gain would do the man an injustice. While hard evidence was not found to prove whether the Downs ran in the red or at a healthy profit, it was not his intent to make money at the endeavor. The legalization of parimutuel betting on horse racing was also not for his monetary benefit but rather to further the interest in Texas-bred Thoroughbreds. And that brings us back to the heart of W.T. Waggoner. W.T. was a cowman, and thus we find the root of his philosophy:

> *All cowmen love horses. The thing that is closest to the heart of W.T. Waggoner, excepting, of course, people, and second only to a good cow and her calf, is a good horse—a saddle horse....Raising horses is an important part of the Waggoner ranch business, for W.T. Waggoner's love for horses is always near the surface of the man. When he will talk of nothing he will still talk of horses, for it instantly carries him back to the old trail-herds, to the dust and smell of the loading pens on scorching days, to open camps and frosty nights of a million stars.[121]*

Disability History in Arlington

By Trevor Engel

UTA's Disability Rights Pioneers

In 1965, three students who used wheelchairs—Sam Provence, Joe Rowe and John Dycus—all began taking classes at Arlington State Collage, now known as the University of Texas at Arlington (UTA). These three laid the groundwork for UTA becoming one of the most accessible campuses for students with disabilities in the nation. These students also used the advocacy skills they developed at UTA to broaden accessibility and expand opportunities for people with disabilities in Arlington and beyond.

After being the last person in Tarrant County to contract polio and subsequently becoming paralyzed, Sam Provence (1949–82) could no longer access public schools. Like most school districts, Arlington ISD had no public schools accessible to students who used wheelchairs. Instead, a teacher periodically came to his house so that he could get an education. After Sam graduated high school, he entered Arlington State College and had the choice of majoring in business or history, as those were the only majors with wheelchair-accessible buildings at the time. He went on to earn his BBA in management and an MA in history. Not only did Provence continually press UTA administrators to better serve students with disabilities, but from the 1970s to the early 1980s, he also served as Arlington's leading advocate for disability rights and greater accessibility.

Left: Sam Provence, September 4, 1970.

Below: Joe Rowe, May 3, 1970.

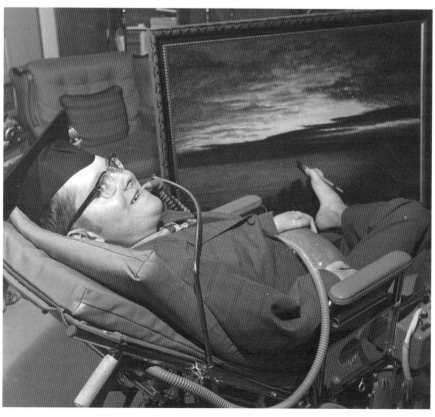

Paralyzed due to polio at age five, Joseph Rowe used his feet to paint pictures and build rockets in his garage. Like Sam, a "home-bound" teacher visited Joe to give him assignments, but he was able to "attend" fourth grade through eighth via a telephone provided courtesy of AT&T. Although he dreamed of majoring in engineering or physics at UTA, a panel of deans told him that he was "too dangerous to allow in the science labs." Rowe graduated from UTA in 1970 as the first business major with a 4.0 GPA. After leaving UTA, Rowe worked with Dallas Area Rapid Transit (DART) to ensure that people with disabilities in Dallas had equal access to the public transit system and helped to develop Dallas County's first independent living center.

Until high school, Fort Worth's John Dycus found himself segregated in special education classes that housed students with virtually every type of disability. Only when a middle school teacher vouched for his intelligence and academic potential did he gain access to standard classes at Paschal High School in Fort Worth. At UTA, John also majored in business due to physical accessibility. He started working for the *Shorthorn* newspaper on campus. Since he could not easily get in and out of the paper's basement office, he developed his editing skills instead of becoming a reporter—a situation that nevertheless turned into a career. After he graduated, John continued working for the *Shorthorn* for thirty-six years, as well as for the *Fort Worth Star-Telegram*. He still volunteers on campus with the newspaper once a week.

The difficulty of navigating inaccessible buildings such as the Science Hall led John to take creative approaches to getting to class. "I had a sociology class in Science Hall's big amphitheater room," he explained. "My mother would stand behind the door when the class let out and peer inside there to make sure I was able to get out. That's before I had the motorized chair and I had to ask somebody to give me a push up the ramp."

John was not alone in having to come up with inventive ways to access classes. He recalls that both Joe's and Sam's mothers played crucial roles in helping them get to classes and being successful in school prior to accessibility improvements on campus. In the 1960s, disabled students also had to find creative ways of getting other students to take notes for them since they often could not do so themselves.

In September 1968, Sam, John and Joseph founded the Handicap Club (soon renamed the Handicapped Students Association) and began pressing the UTA administration to make the campus more accessible. This kind of advocacy was nearly unheard of at the time. In the late 1960s, only the

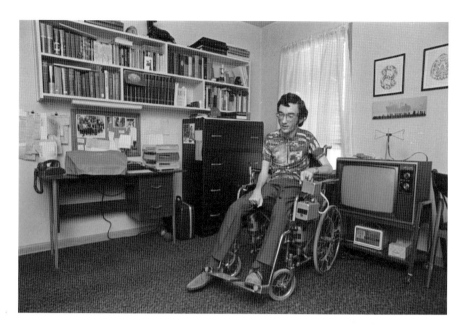

John Dycus, May 15, 1974.

University of Illinois at Urbana-Champaign and the University of California at Berkeley willingly accepted some students with disabilities, albeit with a number of restrictions. In addition, the federally chartered Gallaudet University served deaf students. In one *Shorthorn* article, Sam mentioned that out of the fifty or sixty handicapped students on campus, only fifteen were members of the Handicapped Students Association. Sam made the point that even though they were handicapped, they were still students—and therefore "apathetic." But because of students like Sam, John and Joseph, these students had more access to an education than almost anywhere else in the United States at the time. In fact, Berkeley's heralded Physically Disabled Student Union, which would jumpstart the independent living movement, was founded the year after UTA's Handicapped Student Association.

Since UTA's campus streets lacked curb cuts at corners, the service fraternity Alpha Phi Omega built temporary wooden ramps. The growing number of disabled students at UTA, however, inspired a more permanent solution, especially since heavy machinery and trucks often destroyed these wooden ramps. Drawing on a 1969 Texas law intended to make "public buildings and facilities accessible to, and usable, by physically handicapped and disabled citizens," the Handicapped Students Association asked administrators to provide concrete ramps. Due to this pressure by the HSA,

UTA installed its first curb-ramps—or, as the *Shorthorn* referred to them, "mini-driveways"—in 1970. This was the first permanent solution that offered students with mobility disabilities access at UTA.

"Every curb cut in Arlington should have Sam's name on it," Dycus reflected.

BUILDING A MODEL CAMPUS

Jim Hayes (1949–2008) broke his neck in 1967 on his eighteenth birthday while diving into Lake Benbrook. He had planned to go into the army the day after his birthday but eventually decided to attend Tarrant County Junior College, where he became a dedicated student and, soon, student body president. He transferred to UTA in 1971, majoring in history since he didn't like accounting. As it turned out, Hayes never left UTA and would have a tremendous impact on the campus and the growth of adapted sports in the United States in general.

In 1973, Sam, Jim and the other members of HSA invited President Wendell Nedderman and other administrators to try navigating UTA's campus using wheelchairs. Nedderman recalled, "That was very enlightening. For the first time, it became clear how the men's restroom is a major, major problem. It became clear that a curb, which looks simple to most people, was a major problem. The tour started the real movement toward improving the campus for the handicapped."

Encouraged by administrators, Jim and Sam soon began drafting a fifty-two-page proposal, complete with architectural drawings, of how to make UTA accessible for students with all kinds of disabilities. "I am speaking of a campus which will facilitate unhindered mobility for the general handicapped student, a campus designed or otherwise altered to meet the needs of the more severely handicapped student," explained Hayes. "Indeed, I am speaking of a campus which would set the tone and pace for the removal of 'barriers,' architectural and otherwise, from the educational institutions of Texas."

At a time when disability accessibility often only meant installing ramps for people with mobility impairments—if that—Hayes's proposal included integrated dorms and cafeterias, talking textbooks and sensor devices for blind students, videotapes and interpreters for deaf students and attendants for people who needed assistance with daily living, among other ideas.

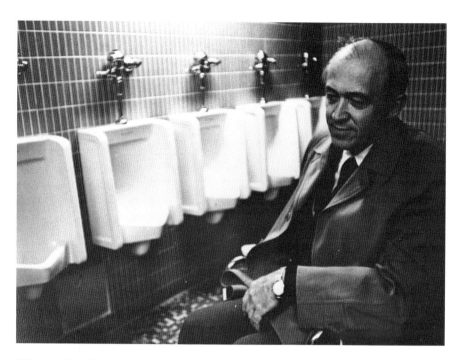

UTA president Wendell Nedderman in a wheelchair on Handicapped Administrators Day, March 21, 1974.

Hayes explained, "When beginning to consider the make-up of a model campus, it is perhaps wise to first focus our attention on adequate housing. There is little doubt that the current facilities are not adequate and to back up that statement, let me cite a very realistic example." He continued, recounting the travails encountered by Sam Provence when he applied to law school. "Sam is an individual with one of the finest minds that I have encountered for a long time. But Sam was denied admission to a Texas Law School because the Texas Vocational Rehabilitation Commission would not fund his education unless he could reside in the dorm. The dorm wasn't equipped for Sam, and he consequently returned to UTA for a secondary choice of graduate work," commented Hayes. He concluded, "The tragedy of it all was that Sam was forced—for better or worse—to compromise on his education because of a lack of facilities. UTA was not adequately equipped either, but it was less hazardous than most. Indeed, adequate housing is a must when preparing for the handicapped student."

UTA administrators' willingness to work with students with disabilities during the late '60s and '70s was vital to the success of disabled students'

activism. UTA is unique in that the students had to fight relatively little to get what they wanted done. For instance, disabled students at the University of Texas at Austin had to file a class-action lawsuit in the mid-1980s just to avoid being charged sixty dollars every semester for the campus's inaccessible bus system.

This is not to say that change was easy, but UTA administrators were unusually attentive and perceptive about the needs of students with disabilities. "The highlight of my career? That UTA became known as one of the best universities in the country to serve disabled students," recalled Wayne Duke, former vice-president of student affairs. "Why did we do that? Well, my philosophy was, well, let's take a student like Sam Provence or many others—by getting an education they'll be able to support themselves and they'll have far more self-esteem. That's what drove me to make this campus as accessible as I could."

Committed, perceptive administrators such as Duke, who terms himself a "person of the people," were far from the only people who sought to make UTA more accessible for students with disabilities. Student Congress regularly passed resolutions calling on the administration to address persistent barriers. One of the first resolutions, passed in 1972, begins, "Whereas, at the present time facilities for the handicapped are shamefully few, and whereas, it is inexcusable for these students to be ignored as they have been, and whereas, a longer waiting period for these facilities compounds the problems of the handicapped…."

Like today, pressure from students was vital for driving change in university practices. UTA had the right combination of disabled student and non-disabled student advocacy, as well as forward-thinking administrators, to make a real difference on campus. The Texas Rehabilitation Commission also awarded UTA $34,000 in 1974 to reduce barriers and establish a disabled student services office run by Hayes. President Nedderman matched this grant with another $34,000. With these funds, UTA added accessible water fountains, remodeled bathrooms, built additional ramps and began a dorm attendant program, among other accessibility initiatives.

Jim Hayes and UTA administrators also worked to raise awareness both within Texas and in the broader Southwest about how colleges could serve students with disabilities. Along with Sam Provence, Hayes pushed the UT system regents to comply with new state and federal laws that required state-funded institutions to be accessible to people with disabilities, including both Texas's 1969 Architectural Barriers Act and Section 504 of the Rehabilitation Act of 1973 (often known as the

first civil rights law for people with disabilities but which the federal Department of Health, Education and Welfare did not put into effect until nationwide sit-in strikes in 1977).

Wendell Nedderman, who served as president of UTA from 1972 to 1992, often spoke with the regents of the UT system, his fellow university presidents and local legislators about UTA's accessibility, pushing them to provide additional funds and raising awareness about the need for colleges to serve students with disabilities. President Nedderman recalled the "Outstanding State Agency" award that the campus received from Governor Briscoe in 1974 for its work on improving accessibility as being a "shot in the arm." He added, "There was pride all over the campus."

Provence, in turn, participated in the Dallas branch of the nationwide grass-roots protests that finally convinced the federal Department of Health, Education and Welfare to issue regulations putting Section 504 into effect in 1978.

As housing director, Kent Gardner, who later became vice-president of student affairs, worked to make dorms like Brazos Hall fully accessible so that disabled students could live on campus with their classmates, among many other projects. He commented, "We had an opportunity as the campus was growing to do not what the law was going to say eventually, but what's right." Working in conjunction with Hayes, Gardner established an attendant system to make it possible for students who needed assistance to live independently in the dorms alongside their fellow students. Such a program was extraordinarily unique for universities at the time, especially outside Berkeley, and attracted disabled students from the Midwest and Great Plains states to UTA.

Despite all the progress made at UTA, the city of Arlington itself lagged behind in terms of accessibility. Between the 1960s and 1980s, pedestrian safety on Cooper Street, a main thoroughfare that bisects campus, was an ever-present concern, especially for UTA's many students who used wheelchairs. Despite a rising toll of injuries, the Arlington City Council, Texas Department of Transportation, UT System Regents and UTA administrators could not agree on a solution. This "eyesore through the middle of campus" was one of the biggest barriers to a safe, and accessible, campus. UTA faculty and students made their voices heard through Student Congress resolutions, letters to the *Shorthorn* and even public protests. These protests, led by Dr. Ulrich Herrmann, routinely blocked cars on Cooper with showings of more than five hundred students and forced the various parties to reach a decision.

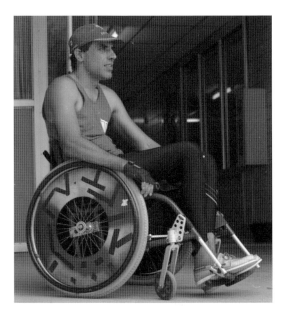

Andy Beck, August 11, 1986.

In the spring of 1989, however, just before construction began on lowering Cooper Street and providing wheelchair-accessible pedestrian overpasses, graduate student and wheelchair athlete Andy Beck was killed while crossing the street.

ACCESSIBILITY BEYOND CAMPUS

What options would UTA's disabled students have after college? Where could they find an accessible place to live and attendants to help them do so independently? How would they get to work or to the grocery store? With the help of fellow UTA alums John Dycus and Jim Hayes, as well as other allies, Sam Provence began to tackle questions like this by founding the Arlington Handicapped Association in 1976. The association advocated for accessible sidewalks, public transit, government buildings and housing codes, among other disability rights initiatives.

In 1981, with the grand opening of the accessible Peach Street Apartments, the association achieved one of its main goals. Residents shared twenty-four-hour attendants, allowing many to live on their own for the first time. Joe Provence, Sam's brother, recalled that "Sam felt free as a bird let loose from a cage when he moved out of our parents' house and into those

apartments." But in 1986, the association almost lost funding for its twenty-four-hour attendant program, which helped forty-plus disabled people live independently and attend college or work. To help raise funds to continue the program, Jim Hayes pushed his track chair 205 miles from Austin to Arlington in two days for the opening of the Sixth National Veterans' Wheelchair Games.

Although enabling people with disabilities to live independently in the community has long been proven to be far cheaper than supporting them in institutions, politicians, especially those in Texas, have hesitated to provide the necessary funds for independent living. As of spring 2017, more than 130,000 Texans are on the waiting list for community-based services. Provence's legacy, however, lives on. Now known as Helping Restore Ability, the Arlington Handicapped Association has grown into the largest nonprofit independent-living attendant provider in the state, operating in every county in Texas and serving nearly 1,000 clients each year with an annual budget of $24 million.

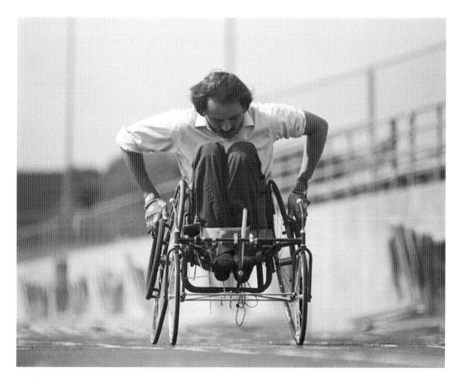

Jim Hayes practices for a 205-mile wheelchair run from Austin to Arlington to raise money for Arlington Handicapped Association, June 17, 1986.

Thanks to pressure from Provence, Hayes, Dycus and others, Arlington established a wheelchair-accessible public transit system in 1979: Handitran. During the city council's deliberations, sixteen-year-old Donna Mack explained how paratransit enabled people with disabilities to be far more integrated into the community. Mack argued, "This will give people like me some independence where we don't have to ask our family, where we can actually go and be employed without inconveniencing other people." This paratransit service proved so helpful and essential to Arlington residents with disabilities that by 1984, passengers had taken more than 100,000 rides. Despite its positive impact on people such as Mack—now a UTA alumna, disability rights activist and the chair of the Arlington Mayor's Committee on People with Disabilities—Handitran has faced repeated funding crises and efforts to defund the program. In 1999, for instance, Mack's eight-year-old daughter Lindsey Anderson also testified on its behalf, explaining, "I ride the Handitran because my mom has a disability. She takes me to school and goes to work." Under pressure from the Arlington Mayor's Committee on People with Disabilities, which was created in 1994, and aided by a Congressional resolution by Martin Frost, the city council held off cutting back paratransit in the largest city in the United States without public transportation.

DRIVING ADAPTIVE SPORTS

"I got a phone call from Jim Hayes in 1976. I didn't know how to play basketball, but he promised me a starting job on the team if I came to the first practice," recalled Ron LaBar, founding Freewheelers (UTA's wheelchair basketball team) member, Vietnam veteran and double amputee. "I just wanted to do something that required physical education. We traveled in an RV with a lift and would play anybody in the first few years—faculty teams, students, the Dallas team."

One of the ways in which UTA has always stood out has been its commitment to offering students with disabilities the opportunity to compete in adaptive sports, particularly wheelchair basketball but also track and tennis. Not coincidentally, wheelchair basketball became a vital aspect of helping administrators and able-bodied students recognize the capabilities of disabled students—a dynamic that has led Arlington and the broader Dallas–Fort Worth region to become a key generator of Paralympic athletes and a major leader in sports wheelchair technologies.

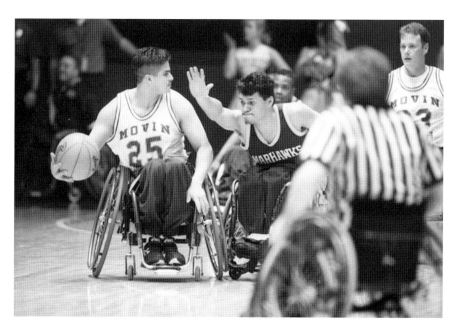

UTA's Movin' Mavs beat University of Wisconsin at Whitewater in the 1994 National Intercollegiate Wheelchair Basketball Tournament semifinals on March 8, 1994. UTA went on to win its fourth consecutive national championship.

"I'll tell you an incident that happened to me which made a powerful impact," recalled former UTA president Wendell Nedderman. "I was impressed with the vigor with which the Freewheelers played. Everybody was out for blood. And if somebody tipped over, too bad. They're going to have to get that wheelchair straightened up and get in that wheelchair by themselves."

During the late 1970s and 1980s, Hayes and the Freewheelers worked to establish wheelchair basketball in Texas and the Southwest playing against community teams, and occasionally other university squads, based around Houston, Texas A&M, UT Austin and others. In order to play more effectively, the Freewheelers often wound up customizing their own wheelchairs. Members of the team would cut apart and re-weld their chairs themselves to tailor them to their individual body dimensions and style of play. With help from disability rights leader Bob Kafka and others, Hayes co-founded the Southwest Wheelchair Athletic Association in 1981. Freewheelers players also helped quadriplegic students who lived in the Peach Street Apartments popularize wheelchair rugby (often known as "quad rugby," which was featured in *Murderball* and *Friday Night Lights*).

Andy Beck's tragic death on Cooper Street in 1989, however, provided the crucial spur to spread UTA's growing expertise in adaptive sports and technology nationwide and beyond. In 1989, the university's Handicapped Student Services initiated the first full-ride scholarship for adapted sports in the country: the Andrew David Beck Memorial Wheelchair Athletic Scholarship.

UTA's new full-ride scholarships for adapted sports enabled the Movin' Mavs (formerly the Freewheelers) to dominate the collegiate wheelchair basketball scene. They won national championships in 1991, 1992, 1993, 1994, 1997, 2002, 2006 and 2017. As a result of their dominance, in 1993 President Clinton invited the Movin' Mavs and coach Jim Hayes to visit the White House. In 2013, UTA added the Lady Movin' Mavs women's wheelchair basketball team, and they won their first national championship in 2016.

Because UTA could use its full-ride scholarships to recruit the best players in the country, other schools had to follow suit and offer full scholarships if they wanted to compete—a dynamic that made college feasible for many more students who used wheelchairs.

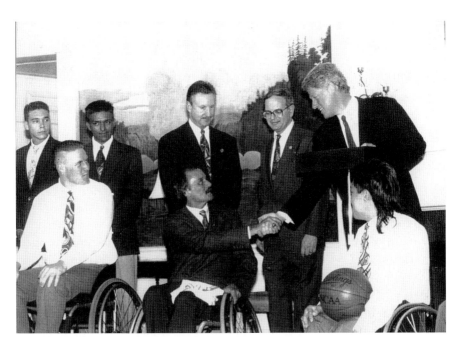

Movin' Mavs coach Jim Hayes shakes hands with President Bill Clinton in 1993. Senator Mike Moncrief and U.S. Representative Martin Frost (wearing glasses) also attended.

UTA alumni such as Willie Hernandez, founder and owner of Per4Max customized wheelchairs and the first recipient of the Beck scholarship, have taken a leading role in developing the lightweight, customized chairs necessary for elite adapted sports. At Per4Max's base in Grand Prairie, Hernandez and his staff of largely Movin' Mavs alumni build hundreds of customized wheelchairs each year, taking into account individuals' centers of gravity, types of disability and styles of play, among other factors.

"I think it's very important that disabled people create their own wheelchairs or at least have a part in the process. As an able-bodied person it's easy to look at something and be like, 'Oh they need this, or they need that,'" commented Movin' Mav alum and Lady Movin' Mavs coach Jason Nelms. Today, Per4Max is the largest producer of sports wheelchairs in the world and is owned and operated by UTA alums, many of whom could afford to attend college only because of the school's adapted sports scholarships.

Since the 1970s, UTA has served as a key training center for elite adaptive sports athletes. Dozens of UTA alumni have gone on to play for the Dallas Mavericks wheelchair basketball team—one of the most dominant teams in the country—as well as professional teams in Europe. As of 2016, thirty-seven Paralympic athletes were enrolled in or had

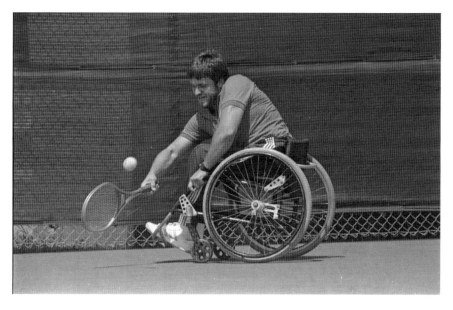

Paralympic athlete Randy Snow plays in a wheelchair tennis exhibition match at Tarrant County Junior College, April 18, 1985.

graduated from UTA. Randy Snow ('86) was just one of nearly thirty Paralympians to train at UTA. He won a silver medal in wheelchair track in 1984, gold medals in wheelchair tennis in 1992 and bronze in wheelchair basketball in 1996.

"At the 2000 Paralympics, I believe there were nine [UTA alums] there from five different countries. That tells you the reach UTA had," commented Movin' Mav alum and Mexican Paralympic team member Cezar Olivas.

In 2016, UTA continued to make a major contribution to the U.S. Paralympic team, with ten UTA students and alumni competing in Rio de Janeiro and UTA students Rose Hollerman and Abigail Dunkin winning gold medals in wheelchair basketball.

DISABILITY AND ARLINGTON TODAY

Disability advocacy in Arlington continues today via many different avenues. The Arlington Mayor's Committee on People with Disabilities recently expanded its charge, committing to "make Arlington the most accessible city in the country." While improving accessibility is an ongoing project, the city of Arlington is gradually becoming a more accessible place to live. The Dallas Cowboys called on the Mayor's Committee, as well as other consultants, on how to make AT&T Stadium and its parking as accessible as possible.

When Arlington resident Rick Frame sued the city in 2005 for failing to provide accessible sidewalks and curb cuts, for instance, he helped to ensure that the city would make ongoing progress. In 2011, the U.S. Supreme Court upheld a lower court's ruling in *Frame v. Arlington* (2011) that Arlington's sidewalks must indeed be accessible by the standards of the Americans with Disabilities Act of 1990. Since then, Frame has worked with the city to identify driveways, intersections and sidewalks that pose barriers.

UTA, too, is becoming ever more accessible by the day. Not only is it renowned regionally and nationally for making college accessible to students with disabilities, but since 2013, UTA has also hosted the first Disability Studies minor in the South. This interdisciplinary program draws students from all across campus to explore the experiences of people with disabilities, as well as the ways in which conceptions and representations of disability and "the normal" have shaped human experiences more generally. Graduates of the program are now coaching adapted sports,

advocating for disability rights, incorporating disability into museums and working in rehabilitation, among other areas, as well as continuing on to graduate school in law, occupational therapy, special education and many other fields. UTA Libraries, in turn, houses the first disability history collection in the Southwest—the Texas Disability History Collection—and is pioneering new ways to digitize historical records so that they are fully accessible to all patrons.

Six Flags Over Texas

By Davis McCown

Six Flags Over Texas held its grand opening on August 5, 1961. Not just an amusement park, it opened under the new concept of a "theme park." Following the lead of Disneyland, the modern park incorporated several areas, with attractions, props, restaurants and gift shops in each area themed to one concept. A handful of such parks opened in the years after Disneyland opened its gates in 1955. Six Flags Over Texas, however, was the only one that survived past a few years of operation.

The park was constructed by the Great Southwest Corporation under the direction of corporate president Angus Wynne. Great Southwest was a land development company in the process of building the nation's largest planned industrial park. Development of the park was facilitated by Arlington's mayor, Tommy Vandergriff, who believed that such a park would be a significant boost to the city's economy.

Neither Wynne nor Vandergriff had any experience in the operation of an amusement park. A relatively new company, Marco Development Corporation, was hired as the design and operation consultant. The principal of Marco Development was Cornelius Vanderbilt (C.V.) Wood Jr. Wood was experienced in the development of theme parks, having been heavily involved in the design, construction and initial operation of Disneyland.

After Disney's initial season, he formed Marco and staffed his new company with many former Disney employees. Marco developed three theme parks between the opening of Disneyland and Six Flags. The first—

Magic Mountain of Golden, Colorado—operated from 1957 to 1959. The second—Pleasure Island in Wakefield, Massachusetts—lasted the longest, operating from 1959 to 1969. Freedomland USA, the largest, operated in New York City from 1960 to its bankruptcy in September 1964.

Great Southwest provided land for the project. A location was picked at the intersection of the Dallas–Fort Worth Turnpike and Highway 360. Construction began in August 1960 and took only one year. The initial park cost $10 million.

The overall theme of the park was the history of Texas. The park was divided into six sections. Each section represented Texas during a period when a different sovereign governed the land: Spain (1519–1821); France (1685–89); Mexico (1821–36); the Republic of Texas (1836–45); the United States (1845–61); the Confederate States (1861–65); and, finally, the United States again (1865–present). Each section was designed to immerse guests into Texas as it existed at the time of one of these sovereigns. To accomplish this, everything from the gift shops and restaurants to the shows and rides were designed around each section's particular period.

The rides and attractions constructed during the first few seasons matched many of those at the successful Disneyland, as well as those at the other Marco parks. These were much less sophisticated than ones that followed in later years. Rather than thrills, the rides offered historic modes of transportation traveling along scenic routes.

The park was originally laid out with one main circular path. The front gate area was a plaza that prominently displayed each of the six flags. The park's path started and ended at the front gate.

To the east of the front gate was the USA section. This section was known as the "Modern" section because it represented contemporary Texas as a state in the United States. The rides were presented with state-of-the-art and futuristic themes. The Modern section featured a petting zoo; one station of the Astrolift cable car ride; the Missile Chaser; the Sidewinder; and miniature gas-powered sports cars running on a track roadway. The modern theme of the section was enhanced by the display of a retired jet fighter.

The Six Flags Astrolift was a cable car ride that reached 55 feet in height and traveled across the park on a 2,100-foot-long steel cable. Such rides were common at the new amusement parks. Guests rode in four-seat gondolas between the USA and Texas sections. The ride was removed at the end of the 1980 season.

Guests road in miniature sports cars at the miniature speedway known as the Happy Motoring Expressway. They controlled the speed of the vehicles

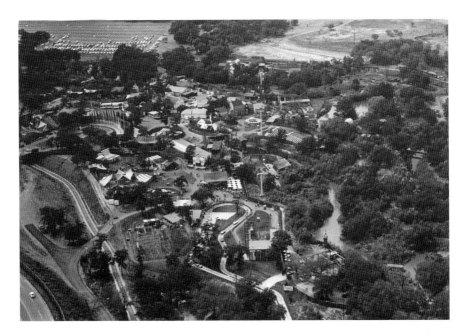

Aerial of Six Flags Over Texas, 1961.

and the direction of the vehicles within the limits of the trackway. Due to the popularity of the ride, a second track and additional cars were added in 1962. The '60s model vehicles were modernized in 1973 to reflect newer car designs. The ride was completely removed at the end of the 1986 season.

The section also featured the park's only two generic carnival-style rides. The Missile Chaser was a standard Scrambler ride, albeit a modern ride for the time. The Sidewinder was the park's first rollercoaster. It was a "Wild Mouse"–style coaster, which was also relatively cutting-edge at the time. A "Wild Mouse" is a small steel coaster with very tight and sudden curves. For the second season, the ride was moved to the Mexican section, where it was renamed the La Cucaracha (the Cockroach). The ride was removed at the end of the 1964 season.

Next to the USA section was the French section. The French claim to Texas consisted of a settlement founded near Matagorda Bay by explorer René-Robert Cavelier, Sieur de La Salle. The French section was designed to resemble a small fort protecting the settlement. The main attraction was La Salle's River Adventure, a riverboat ride that loosely replicated La Salle's efforts to locate the mouth of the Mississippi River. This was one of the park's most elaborate rides and included a Spanish fort that fired cannons

at passing boats and a secret cave entered through doors hidden behind a waterfall. The ride was removed near the end of the 1982 season.

The Confederate section was to the west of the French section. The section was designed to replicate a small antebellum community. Naler's Fried Chicken Plantation, designed like a plantation house, was one of the park's largest restaurants. Several specialty stores were located in the section, including shops that sold various types of flags, a store run by Leonard's Department Store and a store carrying historical books. The name of the section was formally changed in 1997 to the "Old South" section. Most of the original buildings are still in the Old South section of the park. Naler's is now home to JB's Smokehouse Barbeque.

The section was home to the park's largest show, held in what was simply called the "Amphitheater." Presented there were variety shows and an in-house series of musicals presented under the umbrella title of *Campus Revue*. In 1968, the Southern Palace Theater was constructed at the site of the Amphitheater. The air-conditioned theater seats 1,200 guests and is still in operation.

The section was also home to the Confederate drill team and recruitment area. The drill team members were costumed as Confederate soldiers. They performed a street show featuring precision rifle drills. They would also occasionally perform a scripted routine in which a firing squad executed a Confederate traitor or a Union spy. The recruitment center was a replica of a small Confederate camp. Young boys could "enlist" in the Confederate army, and young girls could sign up as nurses. During the 1970s, the award-winning University of Texas at Arlington Jodies Drill Team performed as the Confederate soldiers.

A mule-driven bench carousel ride known as the Lil' Dixie Carousel sat in front of the amphitheater. The name was changed to the Flying Jenny in 1963. In 1968, the ride was moved closer to the Speelunker Cave ride to make room for the Southern Palace Theater. It was removed from the park at the end of the 1974 season. It was the last of four animal-powered rides to be removed.

The Butterfield Overland Stagecoach followed a path in the northwest corner of the park. The ride was based on stagecoaches of the 1800s that delivered mail and passengers across the western frontier. Guests road on life-size horse-drawn replicas of the coaches along a path featuring western props and scenes. The ride was removed at the end of the 1967 season.

The Confederate section was also home to a play activity area named Skull Island. The island was initially accessed by riding on powered log rafts,

Overland Stagecoach, circa 1961–62.

reminiscent of the stories of Mark Twain and the cotton rafts of the South. The island was the home of Skull Rock, a large artificial rock shaped like a skull. A slide extended out of one side of the rock. The Island also held a tree slide, created from a circular fire escape.

The Island was expanded several times after the initial season. Additions included more pathways, a walk-through cave, more tree slides, suspension and barrel bridges, a treehouse and a pirate ship. When the tower was opened in 1969, the Island became accessible by walkways in addition to the rafts. The Island was slowly downsized over subsequent seasons until it was totally removed in 1982.

The Confederate section was also adjacent to the Texas section. The Texas section is based on the years from 1836 to 1845, when Texas was

an independent nation. The section re-creates a typical cowboy town, with many of the structures found in western movies and TV shows. Present are a saloon, a courthouse, a schoolhouse, a bank and various stores. Like the TV shows the section imitated, many of the buildings are scaled down slightly to allow room for more structures in a smaller space.

Gunfights have been a regular feature of the section since the park's opening. Street performers representing the sheriff and his deputies battle against various gangs of outlaws. Most often, the shows are held in front of the courthouse. They have, however, been held in other parts of the section. One routine starts with the train being robbed and ends with a shootout in front of the stationhouse.

The Crazy Horse Saloon is the park's first, and oldest, indoor theater. It is also one of the smallest theaters, with the performers singing and dancing right in front of the audience. Although an imitation of a western saloon, alcoholic beverages have never been sold there.

Across a small bridge is an additional part of the Texas section. Two attractions were originally located in this portion of the park. One was the second station for the Astrolift cable car ride, and the other is the railroad station.

The railroad features two antique steam engines. The General Sam Houston was built by the Dickson Works of the American Locomotive company in 1901. The Charlie Patton was built by the Porter Engine Company in 1897. Both are turn-of-the-century steam engines that hauled sugar on a Louisiana plantation. Each was overhauled by Six Flags before operation. The Sam Houston opened with the park in 1961, and the second engine went online in 1962. The trains ran in a large circle around the park. In 1963, with the addition of Boomtown, the train began making stops on each side of the park. The railroad is the only ride from the first season that is still operating.

The Spanish section represented Texas under the rule of Spain. Like the French section, the Spanish section was rather limited. The section contained a live burro ride during the first and second seasons. The burro ride was based on the explorations of conquistador Francisco Vázquez de Coronado. The burros took riders on a short excursion searching for the seven cities of gold. The burros were replaced in 1963 by the world's first flume ride. The burro ride was the first ride to be removed from the park.

The flume ride was designed and constructed by Arrow Development. In addition to the flume, Arrow provided many other rides at the park, including the miniature cars, the ride portions of the Speelunker's Cave

General Sam Houston steam engine, 2014. *Courtesy Davis McCown.*

El Asseradero (the Sawmill) was the world's first log flume ride. Photo taken circa 1965.

and, later, the Mine Train and the Mini-Mine Train. The flume was the park's first water ride. Unsure how the guests felt about getting wet on a ride, park management became concerned. Arrow was asked to adjust the ride accordingly. After doing so, popularity for the ride dropped off. As a result, the ride was readjusted so that the guests once again received a healthy splash from the ride.

The flume ride proved to be very popular, and a second track was added in 1968. As a result of the popularity of the ride, log flume rides became standard attractions at other amusement parks built during the '70s. Both flumes are still operational.

The border between the Texas section and the Mexican section was the site of the Indian Village. The front of the village was the Trading Post, a souvenir shop specializing in Native American and western items. Behind the Trading Post was a performance area bounded by a set of teepees. Native Americans performed ethnic dances in the performance area. The dance area was removed at the end of 1967, when the second flume ride was added. At that time, the Cyclorama of the American West was added at the back of the store. The ninety-foot cyclorama featured a life-size diorama of Native Americans and western animals. It was removed at the end of 1978 to add a small theater. The theater is now closed, but the Trading Post is still open, selling park souvenirs.

The sixth and final original section was the Mexican section. The park's second railroad, the Fiesta Train, operated in the section. The ride was known as the "Hat Train" to guests due to the oversized sombrero hats that served as the roofs of the cars. It featured small trains that traveled a winding track around various comical scenes. The original scenes on the ride were replaced in 1968 with more dramatic scenes, including a replica sixty-foot-tall volcano that erupted on a regular schedule. The inside of the volcano was the home to a puppet circus.

Goat-driven carts provided a ride experience for the younger guests and completed the park's array of animal-powered rides. Goat-carts were common in the 1900s as a means of transportation. The ride lasted three seasons before being removed.

To round out the section, a large Mexican restaurant provided food, and a large shop sold gifts and souvenirs inspired by Mexican markets. The restaurant was operated by El Chico until 1972.

Adult ticket prices were $2.75 for the first two seasons. This is approximately $22.66 in current dollars. Price increases started with the third year. Although over the years they have decreased from time to time,

overall prices have increased an average of $1.30 per year. As of 2017, daily tickets with no discounts are $76.99. Tickets can, however, be purchased on the internet with a large discount.

Along with the increases in prices came corresponding increases in both the quality and quantity of the attractions provided. It was the intention of Angus Wynne and his staff that the park would constantly grow and change. This philosophy was evident from the beginnings of the park. New attractions and shows are constantly being added to the ever-growing park.

For the second season, the Chaparral miniature car ride was added to the Texas section. In keeping with the park's themes, the ride was named for the 1911 Chaparral, an automobile built by the Cleburne Motor Car Manufacturing Company of Cleburne, Texas. The cars are, however, modeled on the 1912 Cadillac. The ride is still operating, making it the second-oldest ride in the park.

Another addition, a walk-through anti-gravity house, Casa Magnetica, was added in the Spanish section. Anti-gravity houses create the illusion that items are rolling uphill. Such attractions were common at the time at amusement parks and roadside attractions. Although still in the park, Casa Magnetica is no longer consistently operated.

A third attraction, a manually powered Indian canoe ride, was added in the Skull Island area. A trained host guided guests as they paddled a long canoe around the Skull Island pond. The dock for the ride was moved in 1963 to Boomtown. The war canoes were removed after the 1983 season.

The 1963 season brought even more additions. An entirely new section, "Boomtown," was added. Boomtown represented Texas during the days of the oil boom. With the section came two new rides. One was an antique carousel manufactured in the 1920s by the Dentzel Carousel Company of Philadelphia. In 1985, the ride was removed from the park for a major restoration. The ride reopened in 1988 at the park's front gate plaza, where it still operates as the Silver Star Carousel.

The other new ride was the Sky Crane. The ride used a structure based on an industrial crane to lift guests seated in baskets 155 feet into the air. The ride had previously operated at the Brussels' World's Fair of 1958. The ride operated in Arlington until 1968, when it was dismantled and reopened at Six Flags Over Georgia.

The park's first dark ride, the Speelunker's Cave, opened in 1964. The water ride was completely enclosed. Riders traveled through the cave in Indian bull boats. It was populated with "Speelunkers," small fictitious creatures with large banana-shaped heads. The props inside the cave were

painted with incandescent paint that glowed in the dark when lit with black light. This created an eerie atmosphere for the guests. A major scene was a thunderstorm with lightning and thunder. The boats also traveled through the hull of a sailing ship.

The scenes in the ride were changed in 1992 when the ride was rethemed as Yosemite Sam's Gold River Adventure. A new adventure was created for the ride, with Warner Bros. characters and scenes replacing the Speelunkers.

In 1965, the park replaced La Cucaracha with its second off-the-shelf flat ride, El Sombrero. The ride is a large spinning ride constructed to look like a large sombrero. The ride is still in operation. It has, however, been moved twice to different locations within the Mexican section.

Before 1965, all the park's attractions were located inside the railroad tracks that circled the park. That changed in 1965 when an outdoor theater,

Speelunkers, the small, alien-like residents of the Cave ride, took up residence at Six Flags in 1964.

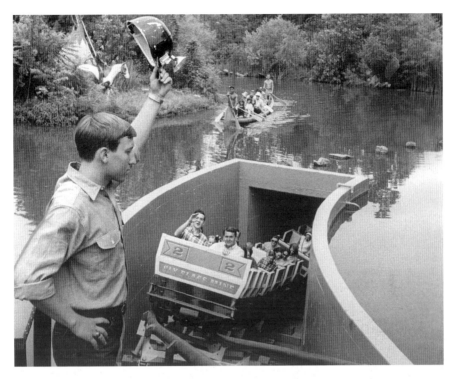

Steve Schellenberg doffs his hat to a group on the Runaway Mine Train, July 24, 1966.

the Texas Arena, was added outside the tracks. The theater was also known as the Texas Pavilion. The Six Flags Circus was featured during the theater's first season. This was replaced with the Wild West Show, which ran for five seasons. For 1970, Los Voladores, the "Flying Indians of Mexico," performed an acrobatic show in the theater. For 1971, the park again featured a Wild West show. That season, the park also began featuring well-known entertainers in concerts in the arena. The arena closed at the end of the 1974 season.

The 1966 season marked a major milestone for the park. Following a season without any rollercoaster, the park installed a state-of-the-art track, the Runaway Mine Train. The million-dollar ride was the park's first large thrill ride. Created by Arrow Development, the ride featured tubular steel, the company's newest innovation. The use of tubular steel tracks allowed wheels on the top, sides and bottom of the track. These additional wheels made possible many features not feasible on previous coasters. This was the world's first mine train rollercoaster and was imitated at many other parks.

The ride was a transition between the scenic rides then in the park and the high-speed rides to come in the following years. Although a rollercoaster, the ride still incorporated the various scenes characteristic of those found on other park rides. The track went under a large rock-crusher, through a cave, behind a waterfall, through a saloon complete with piano player and, finally, through a U-shaped tunnel under Caddo Lake.

The ride did not open until the end of the season and was not fully operational until 1967. Installed in the Boomtown section, the ride was well themed to the section's industrial look. While mild by today's rollercoaster standards, the ride is very popular. It blends the scenes and imagination of the slower-moving rides with the thrills of a modern coaster. A scaled-down version of the ride, the Mini-Mine Train, opened in 1969. It was designed for younger children.

Two new rides were added during 1967. One was the Spindletop, a roto ride named for the famous Texas oil strike. It was installed at the future site of the Krofft Puppet Theater. It was moved the following season to a spot near the tower and later to the site of the Texas Astrolift station. The other was the Jet Set, a unique ride featuring small planes mounted on a beam. Riders on the Jet Set could spin the jets on the beam as they controlled their up-and-down movement. The Jet Set lasted only four seasons before it was replaced by the Big Bend rollercoaster.

Great Southwest also opened Six Flags Over Georgia in 1967, making Six Flags a theme park chain. This was the start of Six Flags' ownership of parks across the nation.

For the 1968 season, the park opened the Sid and Marty Krofft Puppet Theater outside the railroad tracks near the Modern section. Like the Southern Palace, which was constructed the same year, the theater seats 1,200 guests. The show initially featured a show staged by puppeteers Sid and Marty Krofft. The Kroffts were then known for their puppet shows, including a show staged at the New York World's Fair of 1964. They were later known for their TV shows, including *H.R. Pufnstuf*. During the 1968 season, the Kroffts were also instrumental in remodeling the Fiesta Train and in adding large props to the flume ride.

The Kroffts' association with Six Flags ended in the early '70s, and the theater was renamed the Goodtimes Square Theater. Over the years, other productions were staged there, including an animal show, a Bugs Bunny Show and a dance show. The name was eventually changed to the Majestic Theater.

The Six Flags Tower, one of the largest structures in the park, was constructed for the 1969 season. The tower is three hundred feet tall and has

Bob Schmidt controls the puppets behind the scenes at the Krofft Puppet Theater in 1975. The male puppet represents Jimmy Durante.

observation platforms on two levels. When it opened, a super-slide extended from a platform at the fifty-foot level. The super-slide was removed after the 1975 season.

Since the park opened, the management at Six Flags believed that shows were an important part of the mix of entertainment that guests appreciated. In 1968, the park built two theaters. For 1969, it opened two more. The first, the live animal Dolphin Show, opened in a new theater next to the tower. The dolphins performed until 1984, when they were replaced by a diving show. The dolphins returned to the theater in 1989. A Hollywood Cowboy Stunt show was staged there in 1991. In 1992, the theater was torn down. A new theater was built at the same location to feature the Batman Stunt Show. The Batman Stunt Show was replaced in 2001 by the Rangers and Outlaws show, a western production with live animals. The show lasted until 2006. The theater was later used in the fall for haunted houses.

The second new theater was the Chevy Show, a high-tech movie theater. A predecessor to ride simulators, viewers watched high-speed movies on a large circular screen. The movies were filmed from the point of view of different thrill activities, such as skiing and hang-gliding, giving the viewer the "feel" of the activity. The show ran until 1990, when the theater was

renamed the Lone Star Theater. Various shows were staged there over the following years.

A significant change in management occurred in 1970. Beginning in 1964, a subsidiary of the Pennsylvania Railroad began buying shares of Great Southwest Corporation. This continued to the point that Great Southwest was nearly owned by the railroad. In 1968, the Pennsylvania Railroad merged with the Central Railroad to form the Penn Central. The Penn Central, however, filed for bankruptcy in 1970. As a result, the stockholders and lenders required the resignation of all the significant officers of the railroad and subsidiary companies. Although he had nothing to do with the financial problems of the railroad, Angus Wynne was required to resign before Great Southwest could obtain new loans or commercial financing. As a result, outside individuals took over management of Great Southwest and the Six Flags amusement parks. Following the change in management, no major attraction was added in 1970.

The Runaway Mine Train was a huge success and a guest favorite. As a result, another high-tech rollercoaster, the Big Bend, was installed in 1971. The installation of the Big Bend represented a change in direction for the park. Although its rocket-like trains did integrate well into the Modern section, the fast-moving ride did not contain any of the scenes and props that characterized previous rides. The Big Bend operated until the end of the 1978 season. It was removed due to operational issues and not a lack of popularity.

Like 1970, no significant attraction was added in 1972. The next significant addition to the park occurred in 1973, when the park opened an entirely new section, Goodtimes Square. The section was a themed version of a county fair midway. It included a bumper car ride and a Crazy Legs monster ride. The section marked the first appearance of carnival games in the park. The section followed the park's theming pattern in that the area was part of the USA section. The USA section now had three parts: the original Modern USA, Boomtown USA and Goodtimes Square USA.

Another amphitheater opened in 1974. Named the Music Mill, the theater was specifically designed to host performances of popular singers and bands, which the park began hosting in 1971. Occasionally, the park staged its own productions in the theater. For three seasons beginning in 1975, a magic show named Cyrus Cosmos Wonder Show was presented there. In 1990, an ice skating show was presented. In 2007 and 2008, a major production, Cirque Dreams Coobrila by Cirque Productions, was hosted. The theater stage area underwent major renovations to stage this multifaceted show.

A parade throughout the park was featured in 1975. Named the Cyrus Cosmos Incredible Electric Light Brigade Parade, the parade featured the park's new mascot, Cyrus Cosmos, as well as several other characters created for the park. Another parade was featured in 2002 as part of the Best of Texas celebration. A parade celebrating the park's forty-fifth anniversary was held in 2005. It profiled each section, in addition to Justice League and Looney Tunes characters. The park's most elaborate parade was the Glow in the Dark Parade, held in 2009 and 2010.

With the 1976 season, the park continued the trend toward state-of-the-art thrill rides with the installation of the Texas Chute-Out. The Texas Chute-Out was a 175-foot-high parachute tower built near Goodtimes Square and the puppet theater. The ride was an updated version of a 1930s ride that operated at Coney Island. The Chute-Out was removed following the 2012 season after thirty-seven seasons of service. The ride was in the park for more years than any other removed ride.

The thrill rides continued with the introduction of the Shockwave in 1978. The world's first double-looping rollercoaster is extremely popular, as evidenced by the length of the initial lines of guests waiting to ride. The lift hill is 116 feet high, and the trains travel a 3,500-foot track at up to sixty miles per hour. No effort was made to theme the ride to any particular section.

The park introduced its first wooden rollercoaster in 1980. The Judge Roy Scream is located in an area that had been outside the park, accessed by a tunnel under the entry roadway. It features a 65-foot lift hill, 2,480 feet of track and speeds up to fifty-three miles per hour. The naming of the ride was a play on the name of the historical Judge Roy Bean. The coaster remains extremely popular.

The park installed El Conquistador, a standard swinging ship ride, in 1981. Although the ride was promoted as part of the Spanish section, it was in the middle of the Mexican section. This was part of a general degradation of the original theming of the park and began a merger of the Spanish and Mexican sections.

The park's second change in ownership occurred in December 1981. Bally Manufacturing purchased the amusement park chain Six Flags Inc. from Penn Central. Bally was known for its computer games and slot machines.

The Cliffhanger ride opened for the 1982 season. The ride was a free-fall ride with a 128-foot drop. It was another "first of its kind" ride. Although very popular, the ride was later overshadowed by Superman the Ride. It was imploded after the 2007 season.

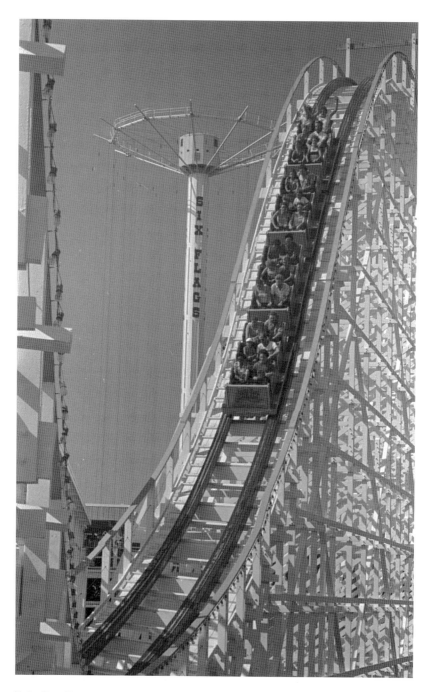

Judge Roy Scream, 1980.

The years between 1980 and 1983 saw the removal of several large early attractions. The Astrolift was removed at the end of the 1980 season. In preparation of the construction of the upcoming Roaring Rapids, both LaSalle's River Adventure and all remains of Skull Island were removed at the end of 1982. The removal of the river ride basically eliminated the French section in the park. In addition, the petting zoo was removed from the Modern section to make room for the upcoming Pac-Man Land. The Indian canoes were removed in 1983.

The Roaring Rapids, a whitewater raft ride contained in an artificial river, opened in 1983. It extends into Boomtown through most of the original French section and contains all of the original Skull Island area. The ride was based on a ride built a few years earlier at Astroworld. The entrance to the ride is located near the observation tower in an area that is not part of any themed section. The units do not ride on any track, allowing the ride experience to vary with each ride. Overall, the attraction leaves riders much wetter than the smaller log flume rides.

A children's play area based on Bally's characters replaced the petting zoo in the Modern section for the 1983 season. The section was converted to Looney Tunes Land in 1985. The area has since grown and been renamed several times but remains a children's activity area themed to Looney Tunes characters.

The Great Air Racer was added in 1984. The Great Air Racer was a large swing-style ride with twelve passenger units shaped like bi-wing airplanes. The planes circled approximately one hundred feet above the ground. The ride was removed at the end of the 1999 season.

The theming of the park took a major change in 1985, when the Six Flags corporation obtained a license to utilize the Warner Bros. Looney Tunes characters in the parks. The agreement resulted from the corporation's purchase of a park already operating under a license with Warner Bros. This license was soon extended to all the Six Flags parks. The Texas park took advantage of the availability of the new characters. Guests could now meet Bugs Bunny, Tweety, Daffy Duck and other Warner Bros. characters. Immediately, the Pac-Man children's area became Looney Tunes Land. The Goodtimes Square Theater was renamed the Looney Tunes Theater. The Modern section stores were restocked with Looney Tunes items.

The Avalanche Bobsled ride was added in 1986. The ride was moved from another Six Flags park. The ride is comparable to a rollercoaster. Instead of riding on a track, however, the ride units travel in a trough. The

units travel freely through the trough, making each ride a unique experience. The ride had no theming relationship whatsoever to the Mexican section in which it was installed. The theming was improved in 1996 when the ride was renamed La Vibora (The Viper). At that time, it was painted with a striped pattern that resembles a snake.

Splashwater Falls opened in the Modern section in 1987. Splashwater Falls, now known as the Aquaman ride, is a simple water drop ride. Guests ride in twenty-passenger boats around an eight-hundred-foot oval waterway. The waterway rises twenty feet into the air and then drops at a thirty-five-degree angle for a major splash.

Wesray Capital Company became the new owners of the Six Flags parks in 1987. No major improvements were made that season. The carousel was returned to the park the following season as the Silver Star Carousel. Instead of returning the ride to its original spot in Boomtown, it was place under a roof at the front gate of the park.

The park increased its rollercoaster count to six in 1989 with the installation of the Flashback rollercoaster. The coaster was added in the Goodtimes Square section. It was a generic rollercoaster known as a "boomerang." A boomerang coaster has three loops contained in a very small footprint. It was removed in September 2012, along with the Chute-Out, in order to make room for the new Texas Skyscreamer swing ride.

One of the largest rides added to the park, the Texas Giant, was installed for the 1990 season. The ride was initially billed as the "World's Tallest Rollercoaster." The initial lift was 143 feet, with a 137-foot drop and 4,920 feet of track. The ride underwent revisions several times over subsequent years. It closed in November 2009 for a complete remake. The ride was reopened in 2011 as the New Texas Giant. The new ride replaced the totally wooden structure with one using a metal rail, which allowed for more exciting elements. The resulting ride was considered a hybrid wood/metal coaster. It was 10 feet taller and a bit faster than the original ride. It now travels at speeds up to sixty-five miles per hour.

Warner Bros. began purchasing interests in the Six Flags chain in 1991 and fully owned the parks by 1993. It sold its interests in the entire Six Flags chain of twelve parks to Premier Parks in 1997.

The Right Stuff Theater, a hybrid theater and ride, was added for 1995. The Right Stuff was a ride simulator with moveable seats controlled by computers. The seats were designed to rotate in synch with the action displayed on a large screen, giving riders the feel that they were part of the action. The area around the ride was themed as part of Edwards Air

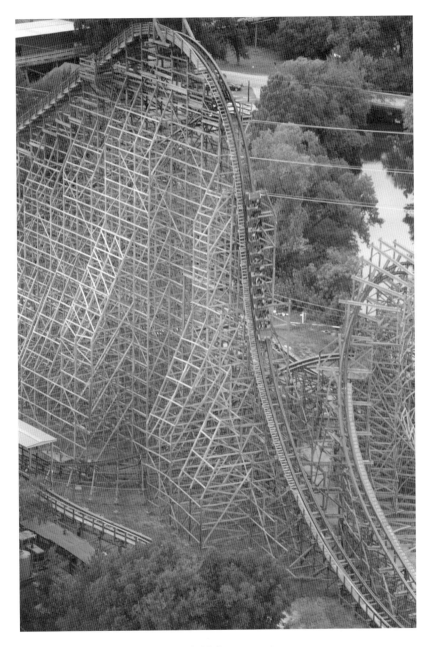

New Texas Giant, 2015. *Courtesy Davis McCown.*

Force Base. In keeping with the air base theming, the names for both the Splashwater Falls and the Cliffhanger were changed.

The theater was configured to allow for different movies to be screened with corresponding changes to the seat movements. The theater name was eventually changed to Adventure Theater 3D. The movie was changed to *Escape from Dino Island 3D* in 1999. In 2002, it was changed to *Space Shuttle America*. It returned to the Right Stuff Theater for the 2003 season. In 2004, it became the *SpongeBob SquarePants Movie*. In 2010, the ride became *Robots of Mars*. In addition, different seasonal movies were shown in the fall and at Christmas. The attraction closed for the last time at the end of the 2010 season. In 2015, the building was converted for use by the Justice League ride.

Following the introduction of the Texas Giant, the park went several years without a major new ride. This ended in 1996, when the park opened Runaway Mountain rollercoaster. The ride is unique in that it runs completely indoors on a dark track. Riders cannot see where they are heading as they travel up to forty miles per hour around the 1,430-foot-long track. The ride opened in the Confederate section.

Runaway Mountain was followed by Mr. Freeze in 1998. The ride was scheduled to open the year prior but was delayed due to technical issues. It was the first of several rides to be named after DC Comics characters. Mr. Freeze is not a continuance track coaster. Instead, the coaster is propelled out of the stationhouse at seventy miles per hour using rare-earth magnets. The cars race through various loops and other elements on 1,300 feet of track. The track terminates with a 218-foot-tall ninety-degree incline. The ride eventually loses energy, slides backward and repeats the same track traveling in the opposite direction.

The following year, the Batman, a suspended looping coaster, opened near Mr. Freeze. The Batman reaches fifty-two miles per hour and features two loops, corkscrew spirals and other elements on a 2,700-foot track. The area around the ride was themed to Batman's home, Gotham City. Both Mr. Freeze and the Batman are still in operation.

Two rollercoasters opened for the 2001 season. The Titan is the longest rollercoaster in the history of the park. It has a 245-foot hill with a 255-foot drop into a tunnel. It travels around a 5,312-foot track at speeds up to eighty-five miles per hour. The ride was installed outside the park over back areas and parts of a parking lot. The other coaster is the Wyle E. Coyote Grand Canyon Blaster rollercoaster. It is designed for younger riders and is in the Looney Tunes section.

Splash Zone featuring Daffy Duck. *Courtesy Davis McCown.*

Another drop ride, the Superman Tower of Power, opened in 2003. The ride is taller than the previous drop rides, standing 325 feet high. The ride features both powered lifts and powered drops. It was constructed at the former site of the Great Air Racer.

Six Flags had not developed its own advertising character since the development of Cyrus Cosmos in 1975. This changed in 2004, when the park introduced Mr. Six, an elderly bald man who broke out in a fast-moving dance to the Vengaboys' "We Like to Party." The reaction to his character was mixed. While many people enjoyed him, others thought that he was unduly creepy.

The park took a new approach to attractions in 2006. Instead of adding a large new ride, ten smaller attractions were added around the park. Nine of the ten rides were off-the-shelf flat rides. A few were relocated from the recently closed Astroworld park. One was a water play area.

In 2008, Tony Hawk's Big Spin was added in the area where the Cliffhanger had stood. The ride was named for extreme-sport athlete Tony Hawk and themed to his skateboard exploits. The rollercoaster was virtually identical to versions installed in several of the Six Flags parks. The ride travels up to thirty-one miles per hour along 1,351 feet of track. The unique feature

of the ride is that the individual ride units spin around 360 degrees as they travel around the track. The ride was renamed the Pandemonium in 2010.

Bankruptcy again affected Six Flags Over Texas when the Six Flags Corporation filed in 2009. The bankruptcy was not due to the inability of the various parks to show a profit each year. Although successful, the profit of the parks was not enough to cover the financing of the amount paid for the parks. During the bankruptcy, this debt was restructured, and the parks continued their operations.

Six Flags Over Texas celebrated its fiftieth anniversary in 2011. In celebration, the park opened the remodeled Texas Giant as the New Texas Giant.

A four-hundred-foot-tall swing ride named the Texas Skyscreamer opened in 2013. The tallest ride in the park, it stands nearly eighty feet higher than the tower and Superman Tower of Power.

The park returned to rides of imagination in 2015 with Justice League: Battle for Metropolis. Instead of intense thrills, the ride is a dark ride in which riders use game guns to shoot at villains from the DC Justice League world. The ride utilizes 3D computer screens in combination with life-size props to create an interactive game experience. Like the 3D theater that was housed in the same building, riders use 3D glasses for the experience.

In 2016, the park expanded the Gotham City section. As part of the expansion, the park named two new rides, as well as one existing ride, after DC Batman comic villains. This villain theme continued in 2017, when the park added the Riddler rollercoaster in the same area. The ride units utilized by the Riddler hang to the side of the track and spin around from top to bottom. By the time of these additions, no remnants of the Goodtimes Square section remained in the park.

Six Flags opened for its fifty-fifth season in 2015. After half of a century, a good number of the original structures remain in the park. It is, however, no longer a small historical park. It has expanded with rides and attractions that dwarf those of the original park. These changes seemed to have worked, as the number of guests visiting the park stays steady over time. The addition of seasonal events, such as Fright Fest and Holiday in the Park, have further boosted the park's attendance. Now owned by a major amusement park chain, the dream of Tom Vandergriff and Angus Wynne should remain a major asset to the city of Arlington for years to come.

SEVEN SEAS

For a short time, Arlington was the home of two theme parks. The second, Seven Seas, was the first major non-coastal sea park in the country. It opened in Arlington to the west of Six Flags in 1972. The park was built in cooperation with Six Flags under the expectation that two major tourist attractions would bring more guests to each park. Originally, it was anticipated that Great Southwest Corporation, which owned the Six Flags parks, would oversee the construction and management of the sea park. However, various legal and financial reasons stemming from the bankruptcy of the Penn Central in 1970 prevented Great Southwest from participating in the park's construction or initial operation. As a result, the City of Arlington was forced to construct and manage the park.

Like Six Flags, this park was divided into sections. Each of the seven sections represented a different aquatic area of the earth and contained one

Children riding in turtle cars at Seven Seas, 1972.

Synchronized swimmers perform at Seven Seas, 1972.

major attraction. These included a high diver show staged on a pirate ship, a 1,200-seat aquatic theater porpoise show and a killer whale theater. There was also a large aquarium exhibit and one major ride, an Arctic sled ride. The Sea Cave was the park's major restaurant. It was located at the front of the park so it could be open all year.

The park was smaller than Six Flags. Attendance at the park never met expectations. First-year attendance was smaller than the forecast, as was the resulting income. For 1973, the attendance fell under that of the year before. With its own management issues resolved, Six Flags Inc. took over the operation of the park in 1974. Live concerts were added in an effort to boost the park, but yearly attendance again fell. ABC-Leisure Marine Inc. took over operation of the park in 1975 but was also unable to improve the attendance.

J&L Enterprises operated the park for 1976, changing the name to Hawaii Kai. Attendance for the year was half that of the year before. J&L Enterprises went bankrupt, and Seven Seas never opened again. The park was eventually dismantled. The Arlington Convention Center, Arlington Sheraton Hotel and a Texas Rangers' parking lot now occupy the area where the park once stood.

The History of UTA Football

THE BEGINNING OF COLLEGE FOOTBALL IN ARLINGTON

No one could have predicted the hold that football would have on Texas when the town of Arlington hosted its first-ever football game on October 1, 1904, between the Carlisle Military Academy Trolleys and a team from Oak Cliff. One imagines the town leaders swelling with pride as the *Arlington Journal* pointed to the game as proof that Arlington was "appropriating to herself all the airs and customs of the larger cities."[122]

A sizeable crowd gathered in ninety-degree heat at Carlisle athletic fields to watch the 4:00 p.m. kickoff. Justin Carlisle, son of the school's founder, was quarterback. The Trolleys lost 10–0, but this setback did nothing to dampen Arlington's enthusiasm for the game.

By 1907, Carlisle had progressed to powerhouse status, amassing 136 points over the season while limiting its competitors to a total of 16. The *Dallas Morning News* reported that "the Carlisle football eleven has yet to meet its equal in this or any section of the State."[123] Perhaps the training conditions at Carlisle helped the team succeed. McKinney High School player William Aural Belden vividly recalled a 1908 game against Carlisle. "The ground was about as hard as a concrete floor," he said.[124]

With two name changes in between, Carlisle became Grubbs Vocational College in 1917 when the Texas legislature established it and John Tarleton

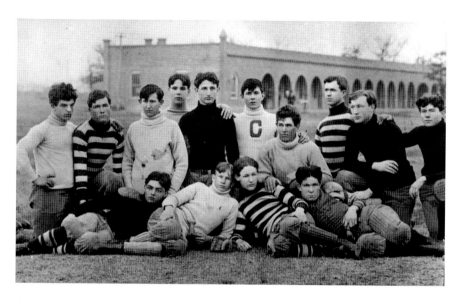

Carlisle Military Academy's football team, circa 1906–7.

Agricultural College (JTAC) in Stephenville as junior colleges in the Texas A&M System. This marked the turning point for the Arlington school from elementary and secondary education to postsecondary education. Grubbs fielded its first football team in 1919. Out of a student body of 143 students, 30 men tried out for the team, coached by Lieutenant L. William Caine.

Athletics were an informal affair. All the players were walk-ons, and academic faculty members coached the teams after classes. Game schedules were "made in accordance with the demands."[125] There were no separate offense and defense teams. "We just played football," said H.A.D. Dunsworth, a former Grubbs student.[126] Many football players also played on the basketball and baseball teams and ran track after the season was over.

Grubbs never established a mascot and was referred to as "Grubbs" in all contemporary news accounts of the team. Decades later, it was said that the mascot was the Grubbworms, but perhaps that was a disparaging nickname given by Tarleton, as there is no evidence that the Grubbworms mascot was ever used by Grubbs.

The team's first game was an away game on October 4, 1919, against Powell Training School in Dallas. It ended in a tie, 0–0. Things did not improve for Grubbs. The *Fort Worth Star-Telegram* generously called the season "rather unsuccessful,"[127] as Grubbs lost every game except one against Fort Worth's Polytechnic High School.

Beginning a decades-long tradition, the final game of the year was played against Tarleton College on Thanksgiving Day. Since Stephenville and Arlington were only about eighty miles apart, roughly the same size and both junior colleges in the A&M System, a fierce sports rivalry started between the schools.

Three hundred fans from Arlington and Stephenville shivered in the Grubbs stands, which were drenched by daylong rain, to see the game. Grubbs intercepted a pass and made the first touchdown of the game. "The crowd cheered for five minutes," reported the *Star-Telegram*. That, however, was the highlight of the game for Grubbs. The paper noted that Grubbs was powerless against a team that outweighed it by fifteen pounds to a man.[128] The final score was 39–7.

Afterward, players from both teams met at the Grubbs dining hall and enjoyed a Thanksgiving dinner of turkey, dressing, cranberry sauce, pies, cakes and more. A dance followed dinner, attended by plenty of female Grubbs students. Tarleton players departed Arlington by train and were given cigars and a box lunch for the ride back to Stephenville.

A report of the event published in Tarleton's student newspaper, the *J-TAC*, complimented Grubbs on the warm reception Tarleton received in Arlington. "It will be a difficult task for [Tarleton] to prove herself more graceful in receiving defeat [than Grubbs]," the article read. "Perhaps it was because of a whole season of practice in this line that Grubbs took the defeat so well." Zing!

In 1923, Grubbs became North Texas Agricultural College (NTAC) and established its team as the Hornets. The Hornets, also called the Jr. Aggies, had their up and down seasons—usually more down than up. Dunsworth, who returned to NTAC as a math professor and coach for football and track, recalled that NTAC wasn't able to do much recruiting of players during the 1920s and '30s. NTAC didn't give scholarships, and the best it could offer prospective players was a twenty-five-cent-per-hour job on campus.[129] "The people we had out for football were strictly volunteers and sometimes we were a little bit short of manpower," said Burley Bearden, UTA coach.[130]

Resources were limited too. The playing field had no press box, so reporters were reduced to holding tow sacks on their heads to protect themselves from rain.[131] "I'll bet our [football] budget wasn't $400," Dunsworth said.[132] Nevertheless, the Hornets won the 1929 Texas Junior College Association title and the Central Texas Conference title in 1934.

NTAC football began a new era with the arrival of coach James Gordon "Klepto" Holmes in 1935. Holmes was only twenty-nine when he came to

coach at NTAC, but he brought a wealth of playing and coaching experience with him. A native of Grand Saline, Texas, Holmes played football for NTAC from 1922 to 1924 before transferring to Texas A&M in 1925. In 1927, Holmes earned a spot on the all–Southwest Conference team. After graduating in 1928, he coached high school for one year and then returned to A&M as a varsity line coach and freshman basketball and baseball coach until 1933.

"Holmes was a great coach," Dunsworth said. "I guess the best student of the game we've ever had here."[133] In Holmes's first season, the Hornets won nine of eleven games—including an 82–0 blowout against Ranger Junior College—and repeated as Central Texas Conference champions. More importantly to the locals, the Hornets beat Tarleton, 16–3, at the annual Thanksgiving game. In the previous eight games, Tarleton won three and NTAC one, and they tied four times.

Tarleton and NTAC had a love-hate relationship, or perhaps a love-to-hate-you relationship. From their cordial beginning in 1919, the NTAC and JTAC rivalry got so intense that the schools broke off their athletic relationship in 1927. According to the *Stephenville Empire Tribune*, the break came because of a "melee" between players and fans of the two schools after the 1927 Thanksgiving game. In that game, Tarleton beat NTAC, 18–7, and secured the state junior college football championship.[134] Tarleton's explanation for the time out, however, was that NTAC just got tired of losing to Tarleton and so called it quits.[135]

The separation ended in 1933 with a resumption of the Thanksgiving Day football game, which ended in a scoreless tie. Everyone seemed eager to make nice, and NTAC put on a dance in honor of Tarleton visitors.

THE BONFIRE INCIDENT

Aggressive displays of spirit soon resumed, however. Tarleton was known to throw rocks at cars and trains coming from Arlington on game day. Students from one school invariably knocked a rival's cap off his head as he passed by at a game.

A favorite prank was to prematurely ignite the rival's bonfire. Spirit bonfires became popular in the 1920s, and students piled scrap wood into a huge tower to fuel the "Big Blaze." The schools got serious about protecting their bonfires, and cadets would patrol the roads into campus on the days

leading up to the lighting of the bonfire. Those captured trying to light the bonfire would be "burred," meaning they would either have a *T* shaved into their heads for Tarleton or an *A* for Arlington.

Bonfire pranking reached its height in 1939. The incident started on November 27, 1939, when about forty JTAC students wearing white coveralls convinced cattleman Beauford Pitman to drive them to Arlington to ignite the NTAC bonfire. Pitman agreed to haul them in his long trailer for twenty-five cents apiece.

The group stopped along the way in Granbury and filled glass jars with gasoline to throw at the bonfire. Mickey Maguire, a Tarleton student at the time, later admitted that it wasn't the best idea. "It was almost like a Molotov cocktail going down the road," he told the *J-TAC* in 2010. "If something had happened or we'd had a wreck, it would have been pitiful."[136]

In Arlington, cadets guarded the NTAC bonfire and gathered around small campfires on the grounds to keep warm in the chilly night. They paid little mind to the truck approaching the bonfire. "Mr. Pitman took that trailer truck and drove it right into the [NTAC] campus," Maguire said. "We were all hunched down in the bed of that truck and in the trailer. I guess we looked like a bunch of sheep in those white overalls."

Once the trailer stopped, the JTAC men shocked the Arlington cadets by scrambling out of the trailer and throwing jars of gasoline onto the bonfire. A few JTAC men picked up glowing embers from the campfires and threw them at the bonfire, causing the pile to erupt into flames. Their mission accomplished, JTAC students raced back to the trailer for a fast getaway. "We were trying to get back on the truck and they were trying to pull us off," Maguire recalled. Those who were not able to get back on the trailer had an *A* burred into their hair and left to find their own way back to Stephenville.

In retaliation, NTAC ROTC lieutenant colonel Nicky Naumovich sent three truckloads of NTAC students down Highway 377 to Stephenville the following afternoon with cans of gasoline and cigarette lighters for the Tarleton bonfire. Tarleton expected the move, however, and was waiting for them on the road. NTAC students were forced to turn around.

What Tarleton didn't expect was the airplane. NTAC was a school certified to train pilots, and so NTAC student Chester Phillips rented a single-engine airplane from Meacham Field in Fort Worth and headed to Stephenville. He was accompanied by freshman James Smith, who would act as bombardier. "Some smart chemistry major made up some bombs of blown glass with phosphorus and water," recalled NTAC student Cecil Roberts. "Two of our

stalwarts would fly down and toss the bombs into the Tarleton bonfire, and at least salvage some of our pride."[137]

The move astounded Tarleton. "All of a sudden, here comes this plane!" Maguire said. Phillips circled to make the first bombing run, and Smith threw a bomb at the bonfire. It hit the target but was extinguished before it could ignite the pile, possibly by Maguire himself, who was standing *on* the bonfire holding a garden hose. "Man, if they had started ours like we started theirs, it would have burned me to a crisp before I could climb down, but I was young and had no care of danger at all," Maguire said.

Smith's other bombs fell in Tarleton dean J. Thomas Davis's yard and on his roof. None ignited. Meanwhile, JTAC quickly recovered from the surprise. Tarleton's bonfire defenders climbed a nearby water tower and began hurling rocks and debris at the low-flying plane. Then JTAC fullback L.V. Risinger hurled a wooden two-by-four at the plane. The board lodged in the plane's propeller and forced an emergency landing.

"Of course the plane sputtered and spurred and almost crashed into Dean Davis' house," Maguire said. But Phillips managed to land safely. When Phillips and Smith emerged uninjured, they were immediately taken

NTAC students watch the game against Tarleton after the bonfire incident, 1939.

captive by JTAC students and burred before being released to an NTAC faculty member.

When game day finally came on November 30, three thousand Tarleton and NTAC fans sat in the cool fall weather to watch the matchup in Arlington, which Tarleton was favored to win. Rain over the previous two days had made the field so muddy that the ball had to be wiped off after each play. The final score was 6–0, Tarleton. Afterward, there was talk of cancelling all games between the two schools as they had done in 1927, but the NTAC and Tarleton deans decided to ban bonfires for a time instead.

As for the students, Smith, the bombardier, was expelled, and Phillips had his pilot's license suspended. Risinger, the Tarleton student who downed Arlington's plane, was hailed as a hero on the JTAC campus and is still honored annually as the "defender of the bonfire during the air raid of 1939."

NTAC AND WORLD WAR II

World War II made hijinks like the bonfire incident seem insignificant. Campus enrollment declined as young men joined the service, and the lack of available talent and money meant that more than 350 colleges throughout the country halted their football programs during the war.[138] In 1943, Texas fielded only eight college or university football teams.

NTAC, however, fielded a team throughout the war. In 1943, the U.S. Navy began the V-12 program to quickly develop more navy and Marine Corps officers. Students in the reserves or who passed a qualifying exam would take college classes at the military's expense on an accelerated schedule; 131 colleges around the country were designated as V-12 schools, including NTAC. Students were shipped to V-12 colleges across the country as the navy required. The navy expected the students to engage in rigorous physical training, and fortunately, football fit the bill. This was a bonanza for NTAC.

The V-12 program dispersed members of powerhouse teams in the Southwest Conference to schools around the country. In June, NTAC coach Klepto Holmes received word that marine reservists—many of whom were top football players from Southern Methodist University, Texas Christian University and Texas Tech—were being transferred to NTAC. "[NTAC] boasts more Southern Methodist University football veterans than SMU

does at the moment," noted *Dallas Morning News* sportswriter Victor Davis. "Ditto so far as Texas Christian University is concerned."[139]

Holmes was as dazzled as a kid on Christmas morning. "Something's bound to happen," he fretted. "I'll never get that ball club on the field."[140]

NTAC's opening game of 1943 was against Southwestern University, which had managed to get an even bigger group of top-notch players. Interest in the matchup was so high that the game was played at Fort Worth's Farrington Field, which could accommodate up to twenty thousand fans. "It wasn't a very exciting game for the simple reason that the Southwestern line was just too good," the *Fort Worth Star-Telegram* reported afterward. Southwestern beat NTAC, 20–0.

Thanks to the range of talent passing through NTAC and the decimation of football veterans at non-V-12 schools, 1943 became the highlight of Holmes's coaching career. That fall saw NTAC beat SMU, 20–6, and Texas Tech, 34–14. The Junior Aggies also held Texas A&M to a scoreless tie. But just as quickly as the players came, they were moved on to their next assignment. "It was not unusual to find a player who had starred at one school the previous season playing for a rival school the next year, after being transferred by the Navy," wrote football historian Bernie McCarty.[141]

By the time World War II ended, about two hundred former NTAC students and faculty had died during the conflict. To honor those who served and those who died, a group of students, alumni, faculty and others decided to build a Memorial Stadium on the NTAC campus. "We believe a stadium to be the most fitting memorial that we could erect to our heroes," said H.A.D. Dunsworth, Memorial Steering Committee member. "We shall remember them as vigorous, loyal, happy young men and associate them with the joy of college sports."[142]

One of the first major fundraising efforts for the stadium was an exhibition golf match at Arlington's Meadowbrook course featuring four-time Texas women's champ Aniela Goldthwaite and retired pro golfer Byron Nelson. NTAC also hosted dances to raise money and exhorted students to donate their textbooks at the end of the semester so that they could be resold and the money given to the stadium fund. Their efforts finally paid off in September 1951, when Memorial Stadium opened with a seating capacity of 5,500. It was expanded to seat 10,000 fans by 1962.

In 1949, NTAC changed its name to Arlington State College (ASC). Since "Agricultural" was no longer in the school's name, the Junior Aggies mascot no longer made sense. The Faculty Athletic Committee called for suggestions and settled on Blue Riders, after the school's colors of blue and white. But

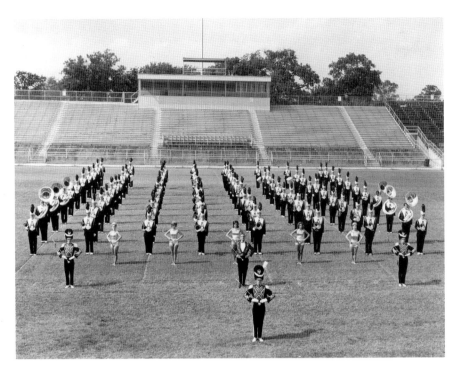

Arlington State College Rebel marching band at Memorial Stadium, circa 1966–67.

Blue Riders never really caught on, and ASC president E.H. Hereford asked the sophomore student body to vote for either Rebels or Cadets as a replacement in 1951. Rebels was the unanimous choice, and soon after, the song "Dixie" became the unofficial fight song and the Confederate battle flag was emblazoned on everything from band uniforms to school trash cans.

CHENA GILSTRAP AND THE JUNIOR ROSE BOWL

Coach "Klepto" Holmes left Arlington to coach freshman football at Texas A&M University in 1951 and was replaced by first Al Milch then Willie Zapalac. Both coaches stayed one season. The arrival of head coach Claude "Chena" Gilstrap in 1953 kicked off a golden age of football at ASC. Newspapers across the state announced Gilstrap's appointment. "He was probably one of the best things that happened to athletics at UTA," Burley Bearden said.[143]

Gilstrap was born in Granger, Texas, as the youngest of eight children and grew up around sports. His father was a competitive marksman, and an older brother, Howard "Bully" Gilstrap, coached at the University of Texas. His sister, Dorothy, was married to Dana X. Bible, head football coach for Texas A&M University and University of Texas. According to Bully, the nickname "Chena" was a corruption of the Spanish word for wildcat (possibly *cachorro*, a wildcat cub) and was bestowed on Claude as a child.[144]

Chena Gilstrap coached high school teams before accepting the head coaching position at Paris (Texas) Junior College, where the Texas Sports Writers Association named him Junior College Coach of the Year for 1948. Gilstrap then moved to Schreiner Institute in Kerrville, Texas, where he amassed a winning record before moving to ASC. His first season at ASC was a success, as he led the team to repeat as Pioneer Conference champions—a feat accomplished the year before under head coach Willie Zapalac.

Off the field, Gilstrap was noted for his quick wit and became a highly sought-after dinner speaker and master of ceremonies: "Smallest crowd I ever talked to, outside of my family, was at a church dinner. I got there and found the tables set for 75 people. Nine showed up. It wasn't so bad, though. They served dessert six times."[145] "Sports writers are about like officials. We couldn't get along without them, but we sure would like to try."[146] "I always left a job by decision. Of course, it wasn't always my decision."[147] "Our [football] program was 100 percent legal because we didn't have enough budget to cheat."[148] "[A football] is a prolate spheroid, four panel; radial dimension, 6.73 inches; radial circumference, 21.25 inches; length, 11 inches; longitude, 28.5 inches; weight, 14 ounces; pressure, 13 pounds. These are the facts. Anything else about football is conjecture."[149]

While Gilstrap was genial off the field, he enforced strong discipline on the field, which led to excellent Rebel teams. The year 1956 became the penultimate season for ASC. In addition to Gilstrap's coaching, the Rebels had a secret weapon: a halfback from Comanche, Texas, named Calvin Lee. Lee, also called the "Comanche Comet" or "Little General," stood five-foot-eight and weighed 147 pounds. In seven games during the 1956 season, Lee compiled 762 yards on 115 rushes and scored 97 points. He was forced to sit out three games later in the season after suffering a knee injury. Even with Lee out, the Rebels finished the season 8-1-1, their only loss coming at the hands of the Tarleton Plowboys.

The loss affected the results of the Pioneer Conference championship. Before the loss, the Rebels had been in the lead for the title. Afterward,

the title was split three ways among ASC, Tarleton and San Angelo (Texas) Junior College.

In November 1956, talk started about the Rebels being a contender for the Eastern spot in the Junior Rose Bowl at Pasadena, California. As co-champions of the Pioneer Conference, Tarleton and San Angelo were also in the running, as were Boise State and Coffeyville, Kansas. California's powerful Compton College team filled the Western spot.

Arlington had a number of things going for it over the other contenders. First, Arlington mayor Tom Vandergriff, a University of Southern California graduate and tireless promoter of all things Arlington, had been lobbying for inclusion on ASC's behalf for years. Second, the field of competition was narrowed because many southern colleges, particularly in Mississippi, refused to let their teams play against integrated teams, of which Compton was one. Third was the location of the school itself. Both Tarleton and San Angelo were ranked significantly higher (3 and 4, respectively) than ASC (11) in the Junior College ratings by the All-American Index.[150] However, as Arlington was a fast-growing community in the ever-expanding Metroplex, it's plausible that the Junior Rose Bowl committee liked the larger media opportunities that Arlington would bring to the game.

Much to Tarleton's irritation, Arlington won the Junior Rose Bowl bid. The team left Fort Worth's Carter Airfield in a chartered plane while the ASC band played on the tarmac. When the team—wearing suits, ties and ten-gallon hats—disembarked at Los Angeles International Airport, a fifty-piece band met them and began playing "Dixie," ASC's unofficial fight song.

California reporters loved Coach Gilstrap's humorous remarks and declared him a "cinch to win the oratorical honors," no matter how the team fared in the game.[151]

"Do you have any out of state players?" a reporter asked Gilstrap.

"We're not particular, down in Texas, who we play on our team so long as they're not Communists or Yankees," he replied with a grin.

"How did your team look this season, overall?" another asked.

"We looked real good against teams weaker than us," Gilstrap quipped.[152]

Compton was definitely not a weaker team. Compton College Tartars won the Junior Rose Bowl in 1946 against Kilgore (Texas) College, 1948 and 1955 and finished the 1956 season undefeated. In fact, the team had not lost a game in three years. While the Rebels were good enough to have gotten to the Junior Rose Bowl, no serious observers expected them to win.

December 8, 1956, was a gloriously mild day, and more than thirty-seven thousand fans packed the stadium. The Rebels were ready to play, but was

Calvin Lee? Lee had missed three games late in the season because of a knee injury that still troubled him. Could he play well against the Compton Tartars? The Baltimore Colts football team provided the answer.

By happenstance, the Colts, who were set to play against the Los Angeles Rams that weekend, were staying in the same hotel as the Rebels. Lee ran into a friend, Colts player "Rolls" Royce Womble from Mansfield, Texas, and told him about his concerns. Womble immediately suggested Lee visit the Colts' trainer. "He said, 'You sure need to go by and see him.' So I did. I hadn't even been able to run, and he taped my knee and it felt like it was brand new," Lee said.[153]

And how. Two minutes into the game, Lee intercepted a pass and ran eighty yards for a touchdown. After two more touchdowns and kicking the extra points, Lee had scored all of the Rebel's points in an astonishing 20–13 upset over Compton. News of the upset and of Lee's stunning performance made news from New York to Fairbanks, Alaska, and was even mentioned in the *Pacific Stars and Stripes* in Tokyo, Japan.

Jubilant Arlington fans rushed the field after the win and tore down the goalposts, which were anchored in concrete. Somehow, they tied the goalposts to the top of the Rebel band's bus and brought them back to Arlington. At home, the city and college hosted an hourlong parade in honor of the win, with team members riding on fire trucks. Students in ASC's baking program created a five-hundred-pound cake made as a replica of the Rose Bowl stadium, with all the players' names written in icing. A dance capped off the day.

Afterward, the band and Sam Houston Rifles installed the Rose Bowl goalposts in front of the student union building. They stayed there until the Hereford Student Center expanded in 1961. Afterward, they were installed in ASC's Memorial Stadium, which was also undergoing an expansion. Their whereabouts are unknown today.

Gilstrap was named the 1956 Junior College Coach of the Year, and Lee was named the game's outstanding player. As ASC was only a two-year school, Lee transferred to Florida State University the following fall.

Expectations were high for the 1957 season. No longer were the Rebels an underdog team—everybody came gunning for them. Reporters from across the country traveled to Arlington to cover Rebel games. "We had quite a good deal of help in the pressbox from the faculty and from the student body….Even some of the girls in Home Economics classes made sandwiches and served sandwiches and Coca-Colas to the visiting press writers," recalled faculty member and administrator Duncan Robinson.[154]

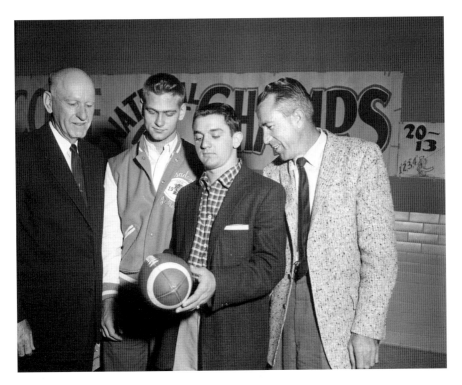

Arlington State College president E.H. Hereford (*left*), Bobby Manning, Calvin Lee (holding football) and Chena Gilstrap after the 1956 Junior Rose Bowl game against Compton.

The Rebels did not disappoint. They avenged themselves against the Tarleton Plowboys (the only team to beat them in 1956), 32–0, and finished their regular season undefeated. "This is the finest group I've ever had in the way of spirit," Gilstrap said. "They have intense desire to do their very best on every down."[155] The Junior Rose Bowl committee agreed and invited ASC back for 1957.

The West was represented by the newly created Cerritos College in Norwalk, California. "Actually, there is no Cerritos College as yet," one newspaper reported. "Students attend classes at a high school at night. The football players are, in 29 cases out of 33, from high schools within the college's district."[156] The story went on to note that the Cerritos football team had no home practice field and used a cow barn for a dressing room. Yet Cerritos was a credible opponent. In this, its first season, it finished 8-1 and scored 234 points to their opponents' 59. The press dubbed them the "Cinderella team," "which rose, in gaudy Hollywood fashion, from an

abandoned dairy farm to the fabulous Rose Bowl in the school's first year of existence," the *Star-Telegram* observed.[157]

But as thirty-six thousand fans watched the game, it was clear that midnight had passed for the Cinderella team. Cerritos fumbled the ball nine times and fell behind 21–5 in the fourth quarter. With 1:05 left in the game, Cerritos scored its only touchdown. The final score was 21–12, Rebels. Many felt that if Cerritos hadn't made so many fumbles, the game could have gone differently. "If they would have made less mistakes and we would have made the same number as we did, they would have beaten us," Gilstrap said.[158]

Gilstrap resigned as head coach in November 1965 but remained at ASC as athletic director, a post he had held in conjunction with his coaching duties since 1957. "If you don't want to quit when you're losing and you don't want to quit when you're winning, this is as good a time as ever,"[159] Gilstrap said. He left as the school's winningest coach with an 85-40-3 record and Southland Conference Coach of the Year honors. He retired from UTA in 1978 and was inducted into the Texas Sports Hall of Fame in 1994. The campus athletic building was named for him in 1995. Gilstrap died in California on August 9, 2002.

THE 1967 PECAN BOWL

When Arlington State College became a four-year institution in 1959, its decades-old rivalry with Tarleton came to an end. Tarleton remained a junior college until 1962 and continued to play other junior colleges, while ASC began playing senior colleges like Sam Houston State, Northeast Louisiana and Southwestern Oklahoma. "When ASC jumped to senior college status, the water got deep in a hurry," Gilstrap recalled.[160]

Still, the team managed winning records for the first three seasons. The year 1962, however, was the start of three consecutive losing seasons. "The bottom kind of fell out there for a couple of years, talent wise," former UTA coach Charlie Key said. "It was interesting watching how [Gilstrap] withstood that."[161]

The Rebs returned to winning form with a 6-3 record in the 1965 season, which was Gilstrap's last as head coach. Burley Bearden, who had been coaching and teaching math at the school since the 1940s, replaced him. When asked to describe his six years as head coach, Bearden said, "I think

we can say that we went from one extreme to the other and we were fortunate enough that we had some fine athletes during this period of time."[162]

In 1967, ASC changed its name to the University of Texas at Arlington. That same year, UTA earned an invitation to the Pecan Bowl after beating Lamar Tech (Beaumont, Texas), 16–10, and winning the Southland Conference championship. The narrow margin of victory was so typical for the Rebs that year that they were dubbed the "Squeak Squad," "Coronary Corps," "Kardiac Kids" or the "Comeback Club."[163] Their Pecan Bowl opponent was the North Dakota State Bison, who, in contrast, had scores like 71–0, 64–19 and 34–0.[164]

The game was scheduled for Saturday, December 16, at Shotwell Stadium in Abilene, Texas, and would be broadcast regionally on television. Two days before the game, a norther brought freezing rain and snow to Abilene. By Friday, ice covered the roads and was blamed for seven traffic fatalities. Two inches of ice covered the football field, and it was expected to get thicker overnight. Pecan Bowl officials debated cancelling the game, but the pending television coverage swayed their decision to play.[165] Still, the ice had to be removed from the field—a job most people said was impossible.

"We called out to Dyess Air Force Base and asked officials there if we could use their huge blowers," said Ham Middlebrook, chairman of the Athletic Committee of the Abilene Chamber of Commerce. "They said we could, but it would take until January for them to thaw the field out. Then for three hours we tried front end loaders and graders, and they couldn't cut the ice—it was too hard. Other types of heavier equipment we couldn't use because they would damage the field," Middlebrook said.[166]

In desperation, members of the Pecan Bowl committee got on radio and television stations and asked for people to show up Saturday morning with shovels and wheelbarrows to clear the ice away for $1.40 per hour. Abilene citizens responded. Before sunrise, about 110 people came to Shotwell Stadium and began shoveling what had, overnight, become six inches of glazed ice. Over four hours, tons of packed ice were carted away in wheelbarrows.

"I've never seen anything like it," said Ed Wagoner, Abilene assistant city manager. "It was sheer guts and determination."[167] Even UTA athletic director Chena Gilstrap came out and shoveled ice.[168]

Miraculously, the field was cleared by 11:00 a.m., and the game kicked off as scheduled at 1:05 p.m.[169] A small crowd of 1,200 spectators huddled under blankets and watched the frigid game played on the muddy field. Players on the bench warmed their feet over buckets of smoldering charcoal,

and cheerleaders in their short skirts kept thermoses of hot chocolate handy. But those who did brave the sub-freezing temperatures saw the Squeak Squad shut out the Bisons and win the game, 13–0. "We're number 1! We're number 1!" chanted the Rebel fans and the players in the locker room. It would be a dozen years before a UTA football team could say that again.

INTEGRATION AND THE REBEL THEME

The late 1940s and 1950s saw a resurgence of the Confederate battle flag across the South in reaction to integration efforts. Arlington State College (ASC) followed the trend by choosing Rebels as the college's mascot to replace the lackluster Blue Riders in 1951. Once the mascot was determined, other motifs of the Confederacy inevitably appeared. Band uniforms sported a large Confederate flag. "Dixie" became the fight song. Student Congress flew the Confederate flag outside the student center. Inside the building, rooms were named for Confederate heroes. Upholstery and draperies were printed with portraits of Confederate generals and scenes of slaves working the fields.

In 1962, however, ASC partially integrated: African American students could attend classes but could not obtain campus housing or participate in athletics. Integrated teams came in 1963 as four African American players joined the football squad. One of them was Melvin "Marvelous Mel" Witt, who went on to play for the Boston Patriots.

The UTA campus newspaper, the *Shorthorn*, editorialized in 1962 that the Rebel theme was no longer appropriate for an integrated school, but the issue garnered little interest or support and was shelved for three years. When ASC changed from the Texas A&M system to the University of Texas system in 1965, the *Shorthorn* again called for a new mascot and theme. "ASC should break even more ties with the past, changing the school spirit theme from the Rebel Dixie motif," the editor wrote.[170] This second attempt had an impact, of a sort. In May 1965, the campus held its first referendum on the school's theme. By a four-to-one margin, students voted to keep the existing theme. The first battle over the Confederate flag was won by pro-Rebel students, but the war—and the referendums—had just started.

In October 1965, twenty-five to thirty students (including eight or nine African Americans) gathered peacefully under the Rebel flag at the student center to protest the Confederate theme. They sang "Freedom" and "We

Theodore Smith (*sitting left*) and an unnamed student attend a pep rally in front of the Hereford Student Center, no date.

Shall Overcome," which attracted the attention of several pro-Rebel students. Heated words were exchanged on both sides. Writing about the event in the spring 1966 *Arlington Review*, African American student Henry Adkins reflected, "I had never really thought of the Rebel theme at Arlington State as degrading to my race because it was never looked upon as a racial issue. But as I began to think of the Confederacy and the Rebel theme 'Dixie,' of the deep southern states that look upon the Rebel flag as some sort of sacred heritage, I began to wonder if such a nice school should have such an evil (in my opinion) associated with it."[171]

African American student James Frank Wyman wrote piercingly about his assessment of the Confederate theme in the fall 1967 *Arlington Review*:

> *For what are we wishing when we so zealously declare, "I wish I was in Dixie?"…You see a beautiful white plantation house with ducks and swans swimming and feeding in the pond. There are beautiful magnolia trees. There are brilliant peacocks spreading their tails on a flower decked lawn*

that descends to the bank of the river....You see a Scarlett O'Hara dressed in flowing silks and satins....That is indeed a very pretty picture....Now I'll turn back my own clock to those same days.

I see my great grandmother shedding tears because her sixteen year old daughter has been sold that morning to a white gentleman from somewhere near Texarkana, never to be seen again....Or worse yet, I see my great grandfather, stripped of all ties with manhood, watching the auctioneer fondle his wife's naked breast before the fluid eyes of whoever was in the market for a black bed-warming wench.[172]

Although publicly calling for the end of the Rebel theme, university administration consistently handed off the decision and responsibility for change to the students. UTA president Frank Harrison wrote to Collegiates for Afro-American Progress (CAP), "The choice of the theme is primarily a student matter....A change in the theme will be recommended by the administration to the appropriate authorities only if supported by a majority vote in a legal referendum of the students."[173]

In the spring of 1968, Student Congress passed resolution no. 132, which called for the end of the Rebel theme. This prompted a backlash in which letter writers called the members of the Student Congress un-American[174] and destroyers of school tradition.[175] Undeterred, Student Congress removed the Confederate flag from in front of the student center in July.

In November 1968, Student Congress put the theme issue to a campus-wide vote. Of the 4,497 votes cast, 3,507 wished to keep the Rebel theme. When asked to explain their position, many white students said they did not consider the Rebel theme and Confederate flag to be racist. Joann Heizer Homer, an ASC student who voted to establish the Rebel theme in 1951, wrote, "The name was chosen, not for anything related to racism, but for what we considered 'Johnny Reb' to stand for, 'a fighting spirit that never dies, honor even in defeat.'"[176] This sentiment was echoed by Kenny Hand, a student at UTA from 1968 to 1972. "To white kids like myself, it wasn't a symbol of racism at all. It was just a symbol of the South and a symbol of the school."[177] Other supporters said the Confederate flag represented a portion of American history and, as such, should not be discarded.

Some wanted to keep the theme because they didn't like feeling bossed around. "I am a veteran of W.W.II and believe in equal rights but to hell with demands and special treatment," wrote one man about the controversy. "This was your theme befor [*sic*] black students were admitted, remember?"

Students protest the use of the Confederate flag at an October 24, 1969 pep rally led by head cheerleader Frank Prochaska.

wrote another, echoing an oft-repeated sentiment that African American students should attend another university if they didn't like the theme.[178]

The pivotal moment of the Rebel theme battle occurred during the fall of 1969. On Friday, October 17, 1969, members of the Kappa Alpha fraternity displayed their fraternity banner, the Rebel flag, at a pep rally. Members of CAP asked the fraternity to take the flag down, but the fraternity refused. A number of CAP members (reports range from ten to seventeen) attempted to capture the flag forcibly, and the resulting shoving match caused two women and one man to be knocked to the ground. CAP then tried to remove a similar flag from the marching band. When that failed, CAP members entered the student center and grabbed several miniature Confederate flags displayed in the building. They brought the flags outside and set them aflame.

The event left the campus shaken and on edge. During a UTA football game on November 8, Arlington police ejected thirty-one black students from Memorial Stadium. According to the complaint filed in U.S. District Court, African American student Forest Alexander Jr. was searching for his seat in the stadium when a plainclothes police officer threw a chunk of ice at him. After exchanging words, several police officers arrived in the stadium section and required all African Americans to leave that section.

When Alexander and the others took new seats, several plainclothes police moved to sit behind them. Suddenly, about twenty uniformed police officers appeared and ordered the group of thirty-one African Americans to leave, for no known cause. After escorting Alexander and the others out of the stadium, police locked the stadium gates behind them and formed a "human barricade" behind the gates to prevent reentry.[179] More trouble happened three days later, when vandals started five trash fires around campus, one set by Molotov cocktail. University officials pointed to tensions over the Rebel theme as the cause. Clearly, the campus needed decisive action to forestall more and greater violence.

By the end of 1969, student opinion had turned to favor the retirement of the Rebel theme. Bill Saunders, president of UTA Student Congress, wrote in 1970:

> *At one time I was one of the theme's strongest supporters. I have evaluated my feelings despite these strong emotional ties and now believe the question is that of finding a good alternative....If the current theme is kept, we must be prepared to meet violence with violence....We have heard much talk about the importance of majority rule. I don't doubt its importance but to rule, a majority must be both responsive and aware of the feelings of a minority....I no longer want to be the president of a divided student body or a campus constantly threatened with violence.*[180]

Student Congress realized that continued controversy was untenable and polled students about using Texans, Mavericks or Apollos instead of Rebels. Texans won the vote, but Tarleton State College had changed from Plowboys to Texans in 1962 and promptly wrote President Harrison saying it would not be appropriate for UTA to have the same theme. UTA disregarded this and held a runoff between Mavericks and Texans in February 1970. Out of only 492 votes, 318 preferred Mavericks.

Not yet satisfied, Student Congress held a March 1970 vote to pit Mavericks against Rebels. Once again the Rebel theme won the majority of votes, but the percentage of victory had dropped from 78 percent in 1968 to 56 percent. Responding to the vote, President Harrison recommended keeping the Rebel theme to the UT System Board of Regents. The regents approved but suggested removing all associations with the Confederacy. So, by the fall of 1970, UTA had its Rebel theme but none of the Confederacy trappings. An ever-growing number of students continued advocating for a theme change, and the ongoing controversy prompted a UTA alum to

upbraid the school for its "wishy-washy indecision. We feel this constant upheaval over the theme—what is acceptable and what is not—must end."[181]

On January 29, 1971, the UT System Board of Regents took the decision away from UTA and voted seven to two to abolish the Rebel theme, effective June 1. Rather than stick to the thoroughly vetted Maverick theme, students voted for a new theme that would definitely replace the Rebels. The four options were Mavericks, Toros, Rangers and Hawks. Only ninety-nine votes separated first-place Mavericks from fourth-place Hawks, so President Harrison called for a runoff between Mavericks and Toros. After seven polls in seven years, the result finally established Mavericks as the new theme.

Now the campus faced a new problem: what is a Maverick? No one at UTA knew, so a committee of students and administrators solicited sketches from area artists and asked students to vote for a winner. The result was an image of a horned horse, which when rendered in profile resembled a unicorn. It didn't last.

For one thing, horses—horned or otherwise—were not allowed on the Arlington Stadium field where the Mavericks were playing after leaving Memorial Stadium. So "a Maverick" became Sam Maverick, loosely based on a real-life Texas land baron and legislator. This cowboy image of a Maverick endured into the twenty-first century with various makeovers, the last coming in 2003. In 2007, students voted to replace Sam Maverick with a new incarnation, a blue and white horse—unhorned—named Blaze.

Few going through the late 1960 and early 1970s imagined a campus unified around one theme, Rebel or Maverick. Writing in 1967, black student James Frank Wyman predicted, "Twenty years from now, Rebel yells will still echo from the stadium and the sound of 'Dixie' will still stir a more patriotic pulse than the National Anthem." In 1971, Rebel theme die-hards wrote to the university administration, "Some Rebels have been at the games, quietly watching the few Maverick supporters quietly display their underwhelming enthusiasm for the new theme. Admit you made a mistake."[182] But from this period of strife and upheaval, the most serious UTA has ever seen, came the most enduring mascot the university has ever had: the Maverick.

TROUBLE IN THE 1970S

From the high of the Pecan Bowl in 1967, 1970 marked a low point with a 0-10 season, after which Burley Bearden resigned as head coach. The year

1970 also saw the Rebels quit playing on campus at the ten-thousand-seat Memorial Stadium (derisively called "the sandlot"[183]) and move to Turnpike Stadium, later called Arlington Stadium.

Turnpike, a baseball stadium, opened in 1965 as a very visible sign that Arlington wanted to attract a major-league baseball team. It originally sat about 10,500 people, but a renovation in early 1970 expanded it to 20,000 seats. Despite the space and modernity over Memorial Stadium, it was not an easy place to play football. To convert it from a baseball field, workers had to remove some bleachers, add sod and erect goalposts—actions that cost thousands of dollars and took a week to complete. The awkward placement of the field at an angle to the stands also meant the fans were at some distance from the action.

In 1972, Arlington finally got its major-league baseball team when the Washington Senators became the Texas Rangers. Turnpike Stadium became Arlington Stadium. While the arrival of the Rangers was a cause for celebration in North Texas, it caused problems for the newly christened Mavericks. First, the Rangers weren't thrilled to be sharing their stadium with a football team. Second, the Rangers had priority on scheduling, so UTA was periodically forced to play home games at a local high school stadium. Third, with the games off campus, attendance dropped precipitously to about three thousand fans per game.

After five consecutive losing seasons (including the 1974 1-10 season), support for the team's future reached an all-time low in 1975. That January, UTA athletic director Chena Gilstrap appeared before the seven-member UTA Student Activities Fee Advisory Committee (SAFAC). He requested $300,000 from student activity fees to fund the athletic department's $500,000 budget, an increase of $28,000. It was a tough sell.

"Don't try to approach the thing as to how much good it does for the number of people who really play the game," Gilstrap told the committee. "The most favorable projection of the image of UTA is the instrument of intercollegiate sports."[184]

Adding pressure to the football budget was Title IX, a 1972 law stating that educational programs receiving federal funds cannot discriminate on the basis of sex. Title IX was most noticeably applied to women's sports, and coaches around the country feared that funding women's athletics would ruin men's athletic budgets. In 1975, UTA women received 8 percent of the athletic budget.[185] "If Title IX means equal funding, we're going to have to cannibalize the men's programs," Gilstrap told the press.[186]

The Mavericks lost to Lamar University at Arlington Stadium on November 26, 1973. Only five hundred people attended the game.

SAFAC, an advisory group that made recommendations to UTA president Wendell Nedderman, was not impressed and voted unanimously, with one abstention, to cut the football budget from student fees. This action would have the immediate consequence of ending the football program at UTA.

The decision incensed head coach Bud Elliott. "I think it is ridiculous that a group of seven students could come up with a recommendation like that," Elliott said. "I would point out that they are an advisory committee of seven students and I think that says something right there about the recommendation. I hate to see students who are going to be here for four years begin to decide what is going to happen to the university as far as the future is concerned."[187]

The UTA Alumni Association agreed with Elliott, recommending to Nedderman that students no longer be allowed to deliberate on issues that "might have lasting effects on former, present, and future students."[188]

Claudia Jennings, SAFAC chairman, defended the committee's decision. "We had to decide which student needs and services are of the highest priority, and football is not a high priority as it is now," she said. Referring to the team's dismal performance of the last few years, Jennings noted, "Publicity for the school is fine, but not negative publicity. These records don't say much for UTA."[189]

Other student groups on campus weighed in on the issue. UTA Student Congress voiced its support of football and passed a resolution opposing SAFAC's recommendation.[190] The student newspaper, the *Shorthorn*, took the opposite stance in an editorial: "This university can no longer justify supporting a financially unproductive football program whose product is by nature predominately entertainment. The university must provide the services and service-oriented programs previously mentioned (legal aid, health care and child care) and let these services be the impetus for increasing enrollment."[191]

For his part, Nedderman told SAFAC he would consider its recommendation. "These ideas are not entirely new," he said. "I don't think anyone disagrees that things are going to have to change."[192]

While SAFAC's recommendation was just that—a recommendation— wide reporting of the issue caused problems for UTA. Recruits were reluctant to sign with a program that might not exist in six months. Sponsors were hesitant to commit advertising funds. Donors held back giving money to UTA. Other teams were leery of reserving a place on their schedule to play UTA. In March 1975, Nedderman attempted to allay these fears by announcing the university's full support for a football program through the

fall of 1975: "UTA is committed to a program of intercollegiate athletics, including a program for women. UTA, contrary to speculation by some, will continue its football program through the fall of 1975. Intercollegiate athletics across the nation are in financial difficulty. The inflationary spiral of increasing costs is having a devastating effect. The results, even during the past 12 months, are significant. UTA, like many other institutions, is facing a financial crisis in its athletic programs."[193]

Then Nedderman admonished his audience: "However, if our football program is to thrive, there must be a marked and substantial increase in interest, in game attendance, and in direct financial support to the program by students, faculty, staff, alumni, and the community."[194]

THE END OF UTA FOOTBALL

Memorial Stadium was razed in 1974, and the continued lack of a stadium on campus hurt attendance numbers at games. Scheduling conflicts with the Texas Rangers forced the Mavericks to move their games from Arlington Stadium to Cravens Field on the Lamar High School Campus in 1977. "At least it's a facility designed for football," wrote *Arlington Daily News* columnist Danny Bush, "and that has to be a pleasant change after seven years in a facility designed for baseball."[195]

But things seemed to be changing in 1977 with talk of building a new stadium on campus. "A facility is the key issue with us as far as recruiting and attracting fans to our home games," Coach Elliott said. "The reality of having a place on campus to play will put us over the hump financially and otherwise. It'll make a difference in the football team, too, in the realization that we are truly a Division I university."[196]

The new $7.5 million, fifteen-thousand-seat stadium (with the ability to accommodate another five thousand temporary seats) opened on September 6, 1980. After a pre-game ribbon cutting by UTA president Nedderman and Arlington mayor S.J. Stovall, the Mavericks welcomed eighteen thousand fans to the first game played on campus in ten years. But in what would be a prelude to the rest of the season, UTA lost 31–14 to the Mean Green of the University of North Texas (UNT). UTA finished the 1980 season 3-8.

Insult was added to injury in 1980, when the new Dallas NBA team chose Mavericks as their name. "Of the infinite number of nicknames that could have been selected, I don't know why Dallas' NBA team picked one

already in use," UTA athletic director Bill Reeves said. "I think it's grossly inconsiderate and I hope our alumni also will remember by staying away from the tickets for a while. I'm really upset by this."[197]

The Dallas Mavericks were unmoved. Norm Sonju, who helped bring the NBA team to Dallas, commented, "I've just recently heard that they were nicknamed the Mavericks. To be blunt, I've lived in Dallas for a year and I never knew that was their nickname until after we had already picked the Mavericks for our name."[198]

Sonju's remark, while cutting, nevertheless substantiated the feeling that UTA football was foundering. Attendance at the new stadium never came close to the crowd that attended on opening day. "More than 50 percent of our 23,100 students live in Arlington, yet student attendance at home football games usually numbers a few hundred," UTA president Nedderman said.[199] "I've been out there [at UTA] when there was nobody there but the band. And that was last year at homecoming," remarked Arkansas State football coach Larry Lacewell.[200] "It's hard [playing before a sparse crowd]," UTA linebacker Brad Robertson admitted. "It's disgusting to go out and see the stands maybe a third full."[201]

The day was sunny and mild when the Mavericks unknowingly played their last home game on November 16, 1985. Their opponent was Louisiana Tech, and UTA lost, 29–14. The next week, the Mavericks traveled to UNT in Denton to play—again unknowingly—their last game ever. UTA lost, 23–20.

At 2:00 p.m. the following Monday, November 25, the hammer fell on UTA football. In a move that stunned the community, UTA president Wendell Nedderman announced what he called "an agonizing decision"[202] to eliminate the football program immediately. Low attendance and a $950,000 deficit finally tipped the precarious balance of football at UTA. "I tried for 13 years [since becoming president in 1972] to develop a viable program and finally decided to throw in the towel," Nedderman later said.[203]

The announcement had a devastating effect on Maverick coaches and players, although Nedderman took great pains to assure them that coaches' contracts would be honored and that players on scholarships would continue to receive aid through their fourth year of study at UTA. "This is a shock, a total shock," Brad Robertson, senior linebacker, said. "We are a family and this is like coming into our family and splitting us up."[204]

"I was looking forward to going all-out next year," Jarvis McKyer, junior tailback, commented. "We had the ideal team. We placed the stones this

Above: UTA sophomore tackle Ed Newman is disconsolate in the locker room after learning that UTA dropped its football program, November 25, 1985.

Left: A few students fought to keep UTA football, November 26, 1985.

year. We kind of had everything planned of how we were going to win the conference next year."[205]

"We've made such great progress," Dean Teykl, sophomore tight end, lamented. "It's a shame a handful of people could flush so many people's dreams down the drain."[206]

"I feel like I've suffered a death in the family," former head coach Chena Gilstrap stated.[207]

"I'm just destroyed," said Athletic Director Bill Reeves.

About two hundred students gathered at Maverick Stadium the day after the announcement in support of keeping football. "That was probably the biggest crowd the team drew all year," Senator Bob McFarland observed. But Ruth Davis of the UTA Maverick Club hoped that fifteen thousand people would show up December 5 as a sign that the community was committed to helping the team. Only one thousand came.

A group of football boosters led by Ruth and Jack Davis immediately started trying to raise $950,000 to cover the program's shortfall. Within one day, it had raised $230,000, most of it a donation from former Arlington mayor Tom Vandergriff,[208] who was driving when he heard news of the cancellation. "I almost lost control of the steering wheel," he said.[209] At the end of the campaign two weeks later, the total was somewhere around $600,000.

Nedderman reaffirmed his decision to drop the sport but said he was glad of the community's efforts on the team's behalf. "It would have been devastating to us if my announcement had been met with silence," he said. "To the members of the Maverick Club, led by Ruth and Jack Davis, to Tom Vandergriff and others, who so earnestly expressed their concern, God bless you. You love UTA."[210]

The now-teamless players could transfer to another school without loss of eligibility or continue at UTA on scholarship. Many were snapped up by other schools. "I remember when coaches from other schools came in to visit the players. It was like kids in a candy store," said Chuck Curtis, UTA's last head football coach.[211] One player on that final team, Tim McKyer, was drafted by the San Francisco 49ers, helped the team win Super Bowls XXIII and XXIV and then helped the Denver Broncos win Super Bowl XXXII.

More than a decade later, the pain of that November day was still there. "It's left some scars," Curtis said, "but it did for all of our coaches."[212]

"It's sad," McKyer said. "It hurt then, and it still hurts. I mean, I'd like to come back to my old school, maybe hang around during spring practice, talk to the players and coaches, help with recruiting, that kind of thing. That would be nice."[213]

EPILOGUE

Despite the vocal outcry in favor of UTA football from a few, the truth about community support for the team was evident from the silence of the majority. UTA professor and pundit Allan Saxe deftly assessed the situation. "If you polled the student body at UTA today," he wrote in 1985, "I have a feeling that 70 percent would say they are not heartbroken over dropping football. Ten percent are heartbroken, and the remaining 20 percent did not know UTA even had a team."[214]

His guesstimate was reinforced by students like Richard Hair. "This is a commuter school," he said. "A lot of students here work and live off campus. Their lives don't revolve around the school."[215]

"Football just doesn't have anything to do with getting good grades and a degree," said Kevin Pitsch, a junior biology major. "I'm probably the typical student, and I've never been to a game."[216]

"I've got better things to do on my Saturday nights than go to football games," agreed a senior student.[217]

"I just come to classes and go home," said another.[218]

Still, more than thirty years after football ended, people still long for its return. Every new incoming UTA president is immediately confronted with the question of bringing back football, but cost and lackluster support of other UTA teams remain pertinent barriers to restarting the team.

"Until we completely support our current teams, until we make sure we're there at all of their games, until we make sure that we really cheer them on—because when they play, they play for us—it's hardly appropriate for us to start a new team," UTA president Vistasp Karbhari said in 2013.[219]

UTA president James Spaniolo commissioned a study in 2004 to thoroughly examine football's feasibility. The report concluded that it would take between $13.78 and $17.45 million over five years to start a new team. In addition, women's sports like soccer and golf would have to be added to comply with Title IX. He ultimately announced that the campus had more pressing needs.

Today, Maverick Stadium hosts university track meets and high school football games. Homecoming, which was celebrated in February for twenty years to coincide with basketball, was moved back to November. Other UTA teams have thrived. In 1989, the volleyball team was the first UTA team to reach an NCAA Final Four in any sport. Baseball won its first conference championship in 1990 and went to the NCAA tournament in 2001. Women's basketball won the Southland Conference Tournament in

2005 and advanced to the NCAA tournament. Men's basketball went to the NCAA tournament in 2008. But the lure of football remains strong. Could it return to UTA? As Chena Gilstrap noted about the game, it's all conjecture.

Notes

Chapter 1

1. *Fort Worth Daily Gazette*, April 1, 1890.
2. William Williams, cook, in 1892 Fort Worth City Directory, at 919 East First Street. Also shown at that address as a laborer in 1895 directory.
3. *Fort Worth Daily Gazette*, "Seven Wounds," October 15, 1890.
4. Ibid., "Midnight Shooting," October 6, 1888.
5. Ibid., "Hargrove's Statement," October 8, 1888.
6. Ibid., "A Race and a Row," December 19, 1888.
7. *Fort Worth Gazette*, "Three Dead," December 24, 1892.
8. Harvey Spear probate record, Tarrant County, 1893.
9. *Galveston Daily News*, "Testimony in Walker Hargroves' Habeas Corpus Hearing," testimony of John Ditto, January 15, 1893.
10. *Fort Worth Gazette*, "Three Dead," December 24, 1892.
11. *Barton County (KS) Democrat*, August 30, 1888.
12. Ibid.
13. *Galveston Daily News*, "Testimony in Walker Hargroves' Habeas Corpus Hearing," testimony of Bill Elliott, January 15, 1893.
14. Ibid., testimony of W.E. Whitaker, January 15, 1893.
15. *Fort Worth Gazette*, "Is It Bailable?," January 13, 1893.
16. *Galveston Daily News*, "Testimony in Walker Hargroves' Habeas Corpus Hearing," Whitaker.
17. Ibid., testimony of James Maddox, January 15, 1893.

18. Ibid., testimony of Elliott.

19. Ibid., testimony of Ferdinand Swann, January 15, 1893.

20. *The Texas Criminal Reports: Cases Argued and Adjudged in the Court of Criminal Appeals of the State of Texas, Walker Hargrove v. The State*, no. 382, decided June 9, 1895, page 431.

21. Ibid.

22. *Galveston Daily News*, "Testimony in Walker Hargroves' Habeas Corpus Hearing," testimony of Bill Routh, January 15, 1893.

23. Ibid., testimony of J.J. Fulford, January 15, 1893.

24. *Galveston Daily News*, "Three Dead Men," December 24, 1892.

25. Ibid., "Walker Hargroves' Preliminary Trial," testimony of Sam Shaffer, January 14, 1893.

26. *Dallas Morning News*, "Three Killed Outright," December 24, 1892.

27. *Fort Worth Gazette*, "Walker Hargrove Arrested," December 26, 1892.

28. *Texas Criminal Reports, Walker Hargrove v. The State*, 431.

29. *Dallas Morning News*, "Jailed for Applauding," February 2, 1895.

30. *Fort Worth Daily Gazette*, "'I'm Sorry,' Says Man Who Killed Walker Hargrove," May 21, 1908.

31. May 20, 1909, unknown publication, found on Ancestry.com.

Chapter 2

32. *Arlington Journal*, "Races at Arlington Downs," advertisement, October 31, 1930.

33. Ibid., "Large Crowd Attends Arlington Downs Race," September 25, 1931.

34. Ibid., "Arlington Downs Awaits Second Horse Races," October 31, 1930.

35. Ibid., "Waggoner Promises Finest Racing Plant for Arlington," no date available, from the Arlington History, files at the Arlington Public Library.

36. Ibid., "Arlington Downs Awaits Second Horse Races."

37. Ibid., "Waggoner Promises Finest Racing Plant.

38. Ibid., "Waggoner Increases Investments in Arlington," Vol. 28, 38, no date available.

39. Ibid.

40. Ibid., "Waggoner Promises Finest Racing Plant."

41. Ibid.

42. Ibid., "Waggoner Increases Investments in Arlington."

43. Ibid., "The 1930 Racing and Entertainment Program Begins November 1, and Continues Eleven Days," October 10, 1930.

44. Ibid., "Waggoner Farms Give Demonstration Races," April 26, 1929.

45. Ibid.

46. Harry Benge Crozier, "Arlington Downs Opens," *Dallas Morning News*, November 3, 1929.

47. *Arlington Journal*, "Horse Races Staged Here by Waggoner Next October," April 26, 1929.

48. *Fort Worth Star-Telegram*, "Horse Racing Condemned by W.C.T.U.," October 18, 1929.

49. *Arlington Journal*, "Barbecue and Private Showing of Horses to Be Given Tuesday," October 18, 1929.

50. Ibid.

51. Ibid., "500 Business Men Visit Three-D Race Track," October 25, 1929.

52. Ibid.

53. *San Antonio Light*, "Arlington Has Strict Rule on Betting," November 5, 1929.

54. *Dallas Morning News*, "Army of Men Working to Finish Course for November Race Meet," August 25, 1929.

55. Ibid., "Dallas Society Contributes Color to First Day Crowd at Arlington Downs," November 7, 1929.

56. *Arlington Journal*, "Arlington Ready as People Arrive for Ten Days of Horse Races," November 1, 1929.

57. Ibid.

58. Ibid., "World's Finest Horses Race Here," November 8, 1929.

59. Leroy Menzing, "Three D Colors Favored," *Fort Worth Star-Telegram*, November 7, 1929.

60. *Fort Worth Star-Telegram*, "Hundreds Attend Open House at Arlington Downs Honoring Stewards of Texas Jockey Club," November 11, 1929.

61. Bernice Foy, "Gay Affairs on Calendar for Debutantes," *Fort Worth Star-Telegram*, November 17, 1929.

62. Ibid., "Friday Is Gala Date for Fort Worth and Dallas Debs," *Fort Worth Star-Telegram*, November 15, 1929.

63. Perry Johnston, "Thoroughbreds Linger to Aid 'Sweet Charity,'" *Fort Worth Star-Telegram*, November 18, 1929.

64. *Arlington Journal*, "Dallas Mayor Won't Pay to See Races," November 22, 1929.

65. Ibid., "The Best Horse Wins," advertisement, November 28, 1929.

66. Ibid., advertisement, November 28, 1929.

67. Ibid.

68. Ibid., "Arlington Downs Awaits Second Horse Races."

69. Ibid.

70. Ibid.

71. Ibid., "Arlington Downs Being Put in Shape for Races," October 24, 1930.

72. Ibid., "Races to Be Held Nov. 1-11," October 3, 1930.

73. Ibid., "1930 Racing and Entertainment Program."

74. Ibid.

75. *Dallas Morning News*, advertisement, November 1, 1930.

76. *Arlington Journal*, "Horse Races Begin Tomorrow," October 31, 1930; Bess Stephenson, "10,000 Make Opening at Downs Style Revue," *Fort Worth Star-Telegram*, November 2, 1930.

77. Stephenson, "10,000 Make Opening at Downs Style Revue."

78. Ibid.

79. Ibid.

80. Ibid.

81. *Arlington Journal*, "Horse Races Staged Here."

82. Ibid., "Races at Arlington Downs."

83. Ibid., "Barbecue and Private Showing."

84. Ned C. Record, "Colorful Scenes to Greet Fans as Meet Opens 10 Days Races," *Record Telegram*, November 6, 1929.

85. Crozier, "Arlington Downs Opens."

86. *The Senate Journal of the Forty-First Legislature*, Regular Session, 1929, 414.

87. Ibid., 451–52.

88. *Arlington Journal*, "Horse Races Staged Here."

89. Ibid.

90. Ibid., "No Gambling Allowed at Race Tracks," November 8, 1929.

91. Ibid.

92. Ibid.

93. Ibid., "Race Fans Lay Bets at Races; Two Arrested," September 25, 1931.

94. Ibid., "Horse Race Bill Passes Legislature," May 19, 1933.

95. S.L. Perry, "Wise, Unwise and Otherwise," *Arlington Journal*, February 1, 1933.

96. *Arlington Journal*, "Texas Racing Bill Now Rider on Appropriations Measure," May 12, 1933.

97. Ibid.

98. Ibid., "Horse Race Bill Passes Legislature."

99. *The Senate Journal of the Forty-Third Legislature*, Regular Session, 1934, 1,794–98.

100. *Dallas Morning News*, "Reformer Makes Bet on Races to Prove He Can, Wins $22.90," November 6, 1934.

101. Ibid., "Racing Comish Moves to Halt Bookmaking on Texas Tracks," November 10, 1934.

102. *Arlington Journal*, "Race Seasons Bring Changes to Arlington," October 26, 1934.

103. Horace Wade, "Downs Again Ready for Big Time Racing," *Arlington Journal*, October 19, 1934.

104. *Arlington Journal*, "Arlington Will Miss Colonel Waggoner," December 14, 1934.

105. *Fort Worth Star-Telegram*, "Memorial Taps to Sound at Downs," November 11, 1935.

106. *Arlington Journal*, "Business Men Favoring Races Go to Austin," March 26, 1937.

107. *The Senate Journal of the Forty-Third Legislature*, Regular Session, 1937, 142.

108. Ibid., 814–15.

109. Ibid., 1,246–47.

110. *The Senate Journal of the Forty-Fifth Legislature*, First Called Session, 1937, 2.

111. *The House Journal of the Forty-Fifth Legislature*, Regular Session, vol. 1, 446.

112. *The Senate Journal of the Forty-Fifth Legislature*, First Called Session, 1937, 38.

113. *Arlington Journal*, "Arlington Downs Being Dismantled Thoroughbreds Sold," July 2, 1937.

114. Martha Williamson, "Huge Army Motor Pool Near Arlington Keeps Military Forces Rolling Along," *Fort Worth Star-Telegram*, February 9, 1943.

115. C.L. Richhart, "Arlington Has Big Crowd Out at First Rodeo," *Fort Worth Star-Telegram*, September 27, 1945.

116. *Fort Worth Star-Telegram*, "8,000 Watch Arlington Parade Opening Rodeo," August 28, 1947.

117. Jack Murphy, "Horn Lauds Downs Track; 6-Wheeler Tested Again," *Fort Worth Star-Telegram*, April 22, 1948.

118. *Fort Worth Star-Telegram*, "GM Is Seeking Storage Space Near Arlington," November 4, 1951.

119. E.O. Alexander, "Wrecking Crew Starts Dismantling Big Arlington Downs Grandstand," *Fort Worth Star-Telegram*, July 13, 1957.

120. *Fort Worth Star-Telegram*, photograph, June 1, 1978, from the Arlington History files at the Arlington Public Library.

121. *Arlington Journal*, "Ranch and Oil Men Know Three-D Brand Old Waggoner Mark," September 27, 1929.

Chapter 5

122. *Arlington Journal*, "Foot Ball," September 29, 1904.

123. *Dallas Morning News*, December 12, 1907.

124. *McKinney (TX) Courier-Gazette*, October 1975.

125. *Grubbs Vocational College Catalogue*, 1917.

126. H.A.D. Dunsworth, oral history with Duncan Robinson, September 26, 1973.

127. *Fort Worth Star-Telegram*, November 25, 1919.

128. Ibid., November 28, 1919.

129. Dunsworth, oral history with Duncan Robinson.

130. Burley Bearden, oral history with Duncan Robinson, August 17, 1978.

131. Duncan Robinson, oral history with H.A.D. Dunsworth, conducted by Robinson, September 26, 1973.

132. Dunsworth, oral history with Duncan Robinson.

133. Ibid.

134. *Empire Tribune*, November 30, 1934.

135. *J-TAC*, November 25, 1933.

136. Erin Cooper, "JTAC vs. NTAC: A First-Hand Account of L.V. Risinger's Heroic Bonfire Save," *J-TAC*, October 21, 2010, 1, https://texashistory.unt.edu/ark:/67531/metapth476114/m1/1/zoom/?resolution=4&lat=7008.412274677132&lon=2020.495567378281.

137. *Yumpu* magazine, "A History of the Department of Military Science at the University of Texas at Arlington (1902 to 1992)," https://www.yumpu.com/en/document/view/27028028/a-history-of-the-department-of-military-science-cadet-corps-alumni-/22#.

138. Robert K. Barney, "Turmoil and Triumph: A Narrative History of Intercollegiate Athletics at the University of New Mexico and Its Implication in the Social History of Albuquerque: 1889–1950," PhD diss., University of New Mexico, 1968, 432.

139. Victor Davis, "Seems to Me: NTAC, Southwestern Get Players," *Dallas Morning News*, July 11, 1943.

140. *Odessa American*, "NTAC Coach Waits for Gratis Team," June 16, 1943.

141. Bernie McCarty, "Football's Greatest Decade," *College Football Historical Society Newsletter*, no. 1 (1987): 2.

142. Memorial Stadium pamphlet, North Texas Agricultural College, Ex-Students Association Records, AR243, UTA Libraries Special Collections.

143. Bearden, oral history with Duncan Robinson.

144. *Arlington Daily News Texan*, "Town and Time," September 22, 1961.

145. Sam Blair, "Life with a Live Mike," *Dallas Morning News*, March 20, 1969.

146. Putt Powell, "Putt Powell's Putting Around," *Amarillo Globe-Times*, December 14, 1977.

147. Richie Whitt, "A Texas Legend," *Fort Worth Star-Telegram*, April 1, 1988.

148. Ibid.

149. George Dolan, "This Is West Texas," *Fort Worth Star-Telegram*, June 24, 1968.

150. *Long Beach Independent*, November 24, 1956.

151. Rube Samuelson, "Give Him a Microphone," *Pasadena (CA) Star News*, December 5, 1956.

152. Ibid.

153. Michael Rychlik, "Rise and Fall—Plight of UTA Football Still Hard for Some to Swallow," *Dallas Morning News*, December 29, 1999.

154. Bearden, oral history with Duncan Robinson.

155. *Fort Worth Star-Telegram*, "Rebs Again Picked for Rose Bowl," December 2, 1957, 12.

156. Jerry Hall, "Cerritos to Face Arlington in JRB," *Long Beach (CA) Press Telegram*, December 2, 1957, 17.

157. Tom Murray, "Rebels Overpower Falcons, 21-12," *Fort Worth Star-Telegram*, December 15, 1957, sec. 2, 1.

158. Jim Galbraith, "Rebels Give Scribe Bath," *Pasadena Independent Star News*, December 15, 1957.

159. Herb Owens, "Gilstrap Surrenders Reb Coaching Post," *Fort Worth Star-Telegram*, November 24, 1965.

160. *Dallas Morning News*, "Retired UTA Coach Winning as a Speaker," December 10, 1978, 13.

161. Jason Hoskins, "Football's Finest," *Shorthorn*, August 26, 2002, http://www.theshorthorn.com/sports/football-s-finest/article_926281db-f361-5b7a-974e-2c8fbf98adee.html.

162. Bearden, oral history with Duncan Robinson.

163. James McAfee, "Pecan Bowl Plagued by Ice-Covered Field," *Abilene Reporter-News*, December 16, 1967, 12A.

164. Ibid.

165. Randy Galloway, "Ice Fills Pecan Bowl," *Dallas Morning News*, December 16, 1967.

166. Buck Schieb, "It Couldn't Be Done—but It Was," *Abilene Reporter-News*, December 17, 1967, 11A.

167. Ibid.

168. Roger Summers, "Gilstrap, Rebels Both Richer," *Fort Worth Star-Telegram*, December 17, 1967, 4B.

169. Schieb, "It Couldn't Be Done."

170. *Shorthorn*, editorial, April 9, 1965.

171. Henry Adkins, *Arlington Review* (Spring 1966).

172. Frank Wyman, *Arlington Review* (Fall 1967).

173. Frank Harrison, "A Statement in Response to a Communication from the Collegiates for Afro-American Progress, to Serve as a Basis for Discussions on March 24, 1969," AR281-1-6, University of Texas at Arlington, Dean of Student Life Records, 1965–70, Special Collections, University of Texas at Arlington Libraries.

174. Letter from C. Alfred Bailey Jr. to Student Government Council, May 1, 1968, AR281-1-5, University of Texas at Arlington, Dean of Student Life Records, 1965–70, Special Collections, University of Texas at Arlington Libraries.

175. Letter from Joann Heizer Homer to Mr. Hensley and Students, May 10, 1968, AR281-1-5.

176. Ibid.

177. Mike Eskridge, "Spirit of Rebellion," *Shorthorn*, March 8, 2000.

178. Rebel Theme Controversy Collection, AR232, 1968–71, Special Collections, University of Texas at Arlington Libraries.

179. *Gene Johnson et al. v. Frank Harrison, et al.*, CA 4-1352, Show Cause Order, United States District Court for the Northern District of Texas, Fort Worth Division, 281-1-7.

180. Bill Saunders, April 15, 1969, AR232, Rebel Theme Controversy Collection, 1968–71, Special Collections, University of Texas at Arlington Libraries.

181. *Dallas Morning News*, "Regents Petitioned for 'Rebel,'" November 21, 1970, sec. A, 18.

182. AR232, Rebel Theme Controversy Collection.

183. Galyn Wilkins, "Football Crossroads: Big Time or Bust," *Fort Worth Star-Telegram*, August 24, 1969.

184. Bill Hickman, "Gilstrap Keeps Busy Pace," *Arlington Daily News*, January 27, 1975.

185. *Fort Worth Star-Telegram*, "Fem Demands Threaten Minor Collegiate Sports," February 21, 1975.

186. Ibid.

187. *Arlington Citizen Journal*, "Panel Kicks Football," February 27, 1975.

188. Ibid., "Alumni, Student Petitions Support Maverick Football," March 4, 1975.

189. *Arlington Daily News*, "Budget Cut Plan Aimed at Football," February 27, 1975.

190. Danny Bush, "Kicking an Issue," *Arlington Daily News*, March 16, 1975.

191. *Arlington Daily News*, "Editorial Takes Anti-Grid Stand," March 20, 1975.

192. Tom Williams, "Mavericks' Grid Future Threatened," *Dallas Morning News*, February 27, 1975.

193. "UTA Administration Backs Football through '75, President Announces," press release by UT Arlington News and Information Service, March 19, 1975, UTA Libraries Special Collections vertical file.

194. Ibid.

195. Danny Bush, "Happiness Is a Home Game," *Arlington Daily News*, October 5, 1977.

196. Randy Cummings, "UTA Gets Green Light for Facilities," *Arlington Citizen Journal*, November 16, 1977.

197. Mike Rabun, "Hostility Greets Mavericks," *Dallas Morning News*, May 2, 1980.

198. Ibid.

199. Donna Darovich, "Last Hurrah for UTA football," *UTA Magazine* 8, no. 2 (December 1985).

200. *Houston Chronicle*, "UTA Move Sparks Protest," November 30, 1985, 6.

201. *Fort Worth Star-Telegram*, "Reactions," November 26, 1985.

202. Darovich, "Last Hurrah for UTA Football."

203. Rychlik, "Rise and Fall."

204. *Fort Worth Star-Telegram*, "Reactions."

205. Ibid.

206. Sam Blair, "UTA Coach Seeks Job; School Rallies," *Dallas Morning News*, November 27, 1985, 11B.

207. Ibid.

208. Max Baker, "UTA Boosters Say Game's Not Over," *Fort Worth Star-Telegram*, November 27, 1985, 1A.

209. Ed Choate, "Boosters Will Seek Reversal," *Fort Worth Star-Telegram*, November 26, 1985.

210. David McNabb, "Boosters' Rally Fails; No Football at UTA," *Dallas Morning News*, December 10, 1985, 8B.

211. Raymond Linex, "Lingering Memory: Curtis Can't Forget UTA Football's Death," *Arlington Morning News*, January 31, 1998, 1B.

212. Ibid.

213. Andy Friedlander, "NFL's Final UTA Alumnus Still Playing," *Fort Worth Star-Telegram*, January 12, 1997, 3.

214. Allan Saxe, "Dropping Football Program Good Move by Nedderman," UTA Libraries Special Collections vertical file, n.d.

215. Sherry Jacobson, "UTA Boosters Shed Tears at Demise of Football Program," *Dallas Morning News*, November 26, 1985, 4A.

216. Ibid.

217. O.K. Carter, "Variety of Maladies Caused UTA Football Death," quote by Andrea Brightwell, *Fort Worth Star-Telegram*, November 26, 1985, 9B.

218. Martha Deller, "Many Students Stunned, Infuriated Over Decision," quote by Trelynda Kerr, *Fort Worth Star-Telegram*, November 26, 1985.

219. Gus Contreras, "Blog: Stop Trying to Make Football Happen," *Shorthorn*, November 27, 2013, http://www.theshorthorn.com/sports/blog-stop-trying-to-make-football-happen/article_70807a7e-5702-11e3-be28-001a4bcf6878.html.

Index

Z

About the Author and Contributors

Evelyn Barker is a librarian at the University of Texas at Arlington. She and co-author Lea Worcester have previously written *Images of America: Arlington, Legendary Locals of Arlington* and *University of Texas at Arlington*. Davis McCown is a Tarrant County attorney and the author of *Six Flags Over Texas: The First Fifty Years*. Leslie Wagner is a metadata archivist at UTA and previously wrote for examiner.com on Dallas history topics. Trevor Engel is an assistant for the UTA Disability Studies Minor and co-curator of the exhibit "Building a Barrier-Free Campus."